SECRET HEREFORD

David Phelps

AMBERLEY

About the Author

David Phelps was born and brought up in Hereford and has a deep love of his native city, even though he now lives on the Herefordshire–Worcestershire border. Since retirement he has spent a great deal of time and effort researching the history and folklore of the area and is the author of six other books, most of them dealing with stories of the Welsh Marches. You can find more about his writing at www.davidphelpswrites.co.uk.

To Valerie Dean, without whose care and love this book would not have been possible.

First published 2019

Amberley Publishing
The Hill, Stroud
Gloucestershire, GL5 4EP

www.amberley-books.com

Copyright © David Phelps, 2019

The right of David Phelps to be identified as the Author of this work has been asserted in accordance with the Copyrights, Designs and Patents Act 1988.

ISBN 978 1 4456 8433 8 (print)
ISBN 978 1 4456 8434 5 (ebook)

British Library Cataloguing in Publication Data.
A catalogue record for this book is available from the British Library.

Origination by Amberley Publishing.
Printed in Great Britain.

Contents

Introduction

Herefordshire has always been a very secret county. Tucked away on the border with Wales, many people confuse it with Hertfordshire and a great number would have difficulty pointing to it on a map. Indeed, from 1974 to 1998 it ceased to exist at all, being amalgamated with the neighbouring county of Worcestershire, an idea that must have looked sensible in Whitehall but was a disaster on the ground.

At the centre of this sparsely populated county lies the city of Hereford. Its strategic position on the border with Wales made it a site of skulduggery and mayhem throughout the Middle Ages, and in later centuries it has been the scene of strange stories, some of which were local nine-day wonders but also others that had national or even international significance.

To the casual observer Hereford seems a quiet little backwater where nothing much has ever happened. This could not be further from the truth. For much of its history Hereford, because of its strategic position near Wales, has been at the centre of British history, and even after the Tudor monarchs assimilated the principality more closely with England, Hereford's fortunes have mirrored the highs and lows of British history. The city's motto,

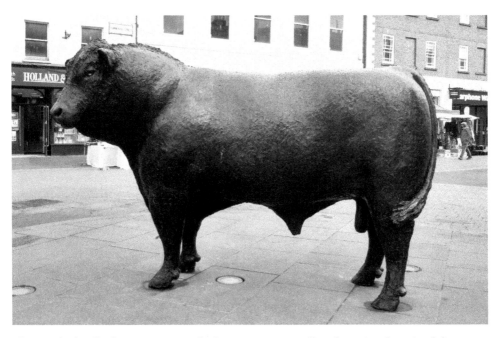

The Hereford Bull. This statue in Hereford town centre proudly referencing the animal that many people associate with Hereford.

'Invictate Fidelitatatis Praemium' – 'reward for faithfulness unconquered' – was awarded by Charles I for standing up to a Roundhead siege in the Civil War. In the glorious way that history plays tricks on humanity, within months of the king's visit and the award of the motto, the city was in Parliament's hands after barely a fight. In the eighteenth century it suffered a slump in fortunes that some people think it has never really recovered from, although that ignores a great outpouring of civic pride during the Victorian period, the fruits of which still enrich the city. In recent years Hereford, as with so many cities, has suffered from post-war standardisation and the cult of progress. A city depends upon the individuals and organisations who live there to safeguard it for the future and this city is blessed with many who are prepared to stand up and protect it against the mindless search for profit. Perhaps people know it now as the home of cider and the SAS, though, as these pages will demonstrate, it has much more to offer.

When I was being taught history back in the late sixties I knew more about the Schleswig-Holstein Question between Denmark and the German Confederation than the history of my native city. Things have improved now and local history is a thriving topic. I hope this book will be of value to Herefordians looking to know more of their heritage as well as visitors anxious to know more about what they are seeing. There has never been a better time to be interested in local history, with many online resources and books now readily available. With this in mind I have tried to live up to the spirit of the title of this book and have sought out, within a comprehensible narrative, some of the more out of the way details of the history of the city of Hereford that are not otherwise easily available.

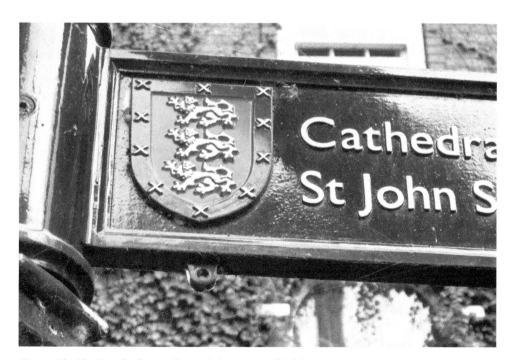

Civic pride. The Hereford coat of arms helps tourists find their way.

1. Pre-Roman and Roman Era: A Time Before Hereford Even Existed

The Rotherwas Ribbon

In 2008, during the construction of a controversial road 2 miles to the south-east of the city, a mysterious serpentine trackway of fire-cracked pebbles interspaced with white quartz was discovered curving its way up a hillside from the River Wye to Dinedor Hill, the site of a later hill fort. Its purpose is disputed, since it was only one stone deep so could not be a pathway but must have looked spectacular, glinting in the sunlight or glowing by moonlight. It has been dated to around 2000 BCE and is unique not just in Britain but in the world. Despite this Herefordshire Council insisted that it be covered up as quickly as possible and the road, though little used, was built over it.

DID YOU KNOW?
Hereford is built on Old Red Sandstone, a rock laid down in the Devonian period, around 400 million years ago, and formed from lake and river sediments. It has always been considered an excellent building material, as can be witnessed from its use in Hereford Cathedral.

The Rotherwas Ribbon, a mysterious and now buried ancient discovery.

Above: The Rotherwas Ribbon in the landscape where it would have wound its way up the hill.

Right: Hereford Cathedral, which is made out of the local old red sandstone.

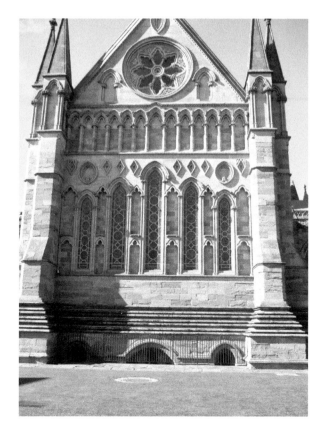

Dobunni

In a time before written records nothing can be certain but, from coin records, the area surrounding Hereford appears to have been in the control of the Dobunni tribe, whose main centres were at Cirencester and Gloucester, but probably had a population base in the vicinity of Credenhill, the second largest Iron Age fort in Britain. Possibly for this reason, when the Romans arrived the location was chosen as their principal site in the area, setting their town of Magnis at the base of the hill. While the Dobunni seem to have welcomed Roman civilisation, the Silures, the tribe in control of west Herefordshire, were less enamoured of underfloor heating and hot baths and made life as difficult as they could for the Romans for several centuries.

Experts now think that the waning of Roman influence on these islands did not lead to the descent into anarchy that was previously believed. More a taking back control and the rule of more local warlords. At least until the Anglo-Saxons arrived.

DID YOU KNOW?
The Dobunni were early adopters of the newfangled concept of coinage, an idea they borrowed from the Continent. Farmers and detectorists are still unearthing them and, thanks to the inscriptions on the coins, we know their chiefs had names such as Bodvoc, Catti and Curio. They often depict a horse or a mysterious branch-like object, which might be a symbol of fertility.

Credenhill, the largest Iron Age fort of the Dobunni.

Kenchester was once a Roman town, but is now farmland.

Iron Age huts. These are similar to those that would have been lived in by the Dobunni.

2. Anglo-Saxon Period:
The First Foundations
of a Great City Are Laid

Magonsaete

With the advance of Anglo-Saxon rulers in the sixth century, the area now known as Hereford came under the control of a tribe known as the Magonsaete. Diocese boundaries are thought to reflect those of early Saxon tribes so the Magonsaete probably extended into what is now southern Shropshire and along the Wye, incorporating western Worcestershire but did not include western Herefordshire, which remained Welsh/Celtic. With the rise of the powerful kingdom of Mercia in the late eighth century, the Magonsaete were subsumed into its control.

Hereford

The city of Hereford owes its existence to two factors. Firstly its strategic position. Hereford, in Anglo-Saxon, means ford where an army can cross, an important thing to know about in this troubled period. There had probably been a river crossing here since Roman times, possibly just to the west of the cathedral, but, with the Welsh border becoming increasingly disputed, in this period it took on greater importance. Originally its boundaries ended at what is now Castle Street. By 930 it had its own mint, making coins for King Athelstan, grandson of Alfred the Great and the first man who could call himself king of all the English.

The site of the original River Wye crossing.

Castle Street, the early Saxon boundary of Hereford.

DID YOU KNOW?
Hereford might have been called Fernlea. This was an earlier name for the area, which means a 'ferny clearing'. The name was still occasionally used into the early medieval period but the ferns were giving way to buildings and the strategic setting was increasingly important.

Hereford Cathedral

The second and most important factor was the development of Hereford Cathedral. Unfortunately the story of the foundation of the cathedral is somewhat clouded in the mists of lost paperwork. Early bishops did not have a diocese but were expected to be wandering preachers around a tribal kingdom. There is some indication that there was a bishopric here in the 670s but the first bishop for which we have a name is Putta, dating from the 680s, who retreated here after being thrown out of Rochester by Athelred, the pagan king of Mercia. With the cathedral came trade and tradespeople, especially after the development of the cult of St Ethelbert, which enabled the cathedral to be upgraded from a wooden to a stone structure.

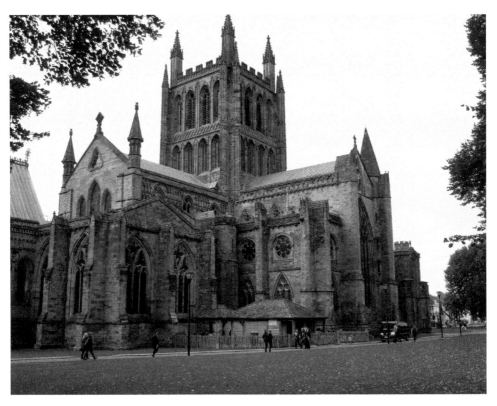

Hereford Cathedral is still the most substantial building in the city.

St Ethelbert

How did an obscure king of East Anglia become the patron saint of Hereford Cathedral? If we are to believe monkish chroniclers, it was all the fault of women. Ethelbert had fallen in love with the daughter of King Offa and travelled to Offa's palace in north Herefordshire to plight his troth. However, Offa's jealous queen persuaded him that a dead son-in-law was better than a live one and Ethelbert was beheaded, although early chronicles are full of evil women martyring innocent young men so this can be discounted. It should be noted that this incident occurred in AD 794. The first Viking raid took place on the east coast in 792 and it might be that Offa felt he had to be in greater control of strategic East Anglia. Whatever the truth, after Ethelbert was buried in Hereford Cathedral a series of miracles were reported at his tomb. Soon Ethelbert was canonised and it became a popular shrine for pilgrimage, but this wasn't to last.

Saxon Defences

Aethelflaed, Lady of the Mercians and daughter of Alfred the Great, continued her father's strategy of fortifying towns to resist Viking and Welsh attacks and Hereford was her most westerly burh. Although some defensive works must have already existed, given Hereford's situation, it is inevitable that Aethelflaed greatly improved them. Uniquely a part of the Saxon defences can still be found behind a block of flats at the corner of

A modern reimagining of St Ethelbert's Tomb after the original was destroyed by the Welsh in 1055.

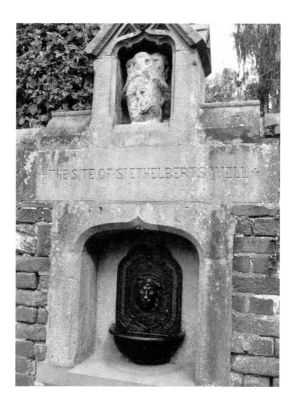

St Ethelbert's Well. This is where the body of the saint rested overnight before being buried in the cathedral, and a miraculous well sprung forth.

These are the only Saxon stone defence works currently visible in England.

A modern embankment reflects the original Saxon wall.

St Owen Street and Cantilupe Street and the ramparts of the car park in Victoria Street probably follow the embankments of the Saxon defences. At the time the northern boundary of the settlement extended only as far as High Town.

The Battle of Hereford, 1055

For once all the Welsh kingdoms were united under Gruffydd ap Llywelen, which gave this mighty warlord the opportunity to invade Herefordshire. To counter this threat Edward the Confessor sent his nephew, Ralph of Mantes, recently created Earl of Hereford. Unfortunately Ralph, trained in Norman warfare on horseback, insisted that his Saxon warriors adopt this tactic, even though they were untrained in it. Inevitably chaos ensued and Ralph and his men were routed and beat a hasty retreat to the safety of Hereford castle, allowing the Welsh to sack Hereford, especially the riches available in the cathedral. About 500 of the townspeople and clergy were killed with no loss to the invaders. In the course of this the tomb of St Ethelbert was completely destroyed. Ralph was known forever after as Ralph the Timid.

DID YOU KNOW?
There was once a monastery in the Castle Green. One of the earliest monastic establishments in the area, it was dedicated to St Guthlac, another East Anglian saint, possibly due to close connections between the kings of Mercia and that area and that Guthlac, as a young man, had fought in the army of Aethelred. While this location had worked in the early years of the castle's existence, as it became busier the monastery became a bit of an inconvenience and it was moved to a site near what is now the bus station. Destroyed at the Reformation, there is now no trace of it.

Castle Green, the former site of St Guthlac's Priory.

3. The Middle Ages: Hereford Becomes One of the Most Important Cities in the Kingdom

At the time of the Domesday Book there were 103 families dwelling in the town, whose houses were just scattered around the vicinity of the cathedral. Soon after the Norman Conquest the settlement was enlarged to the area within the stone city walls.

The Use of Hereford

Probably brought to Hereford by Bishop Gerard soon after the Norman Conquest and adapted from that of his native Rouen, the order of prayer and services that were used in the cathedral became popular in many other churches in the west of England, rivalling those of Salisbury and York. It was suppressed in 1549 when the Book of Common Prayer was imposed as the only form of religious service that could be used in England.

The Anarchy

When Henry I died in 1135 he left no direct male heir. Two of his relatives thought they should be the next monarch, his daughter Matilda and his nephew Stephen. So began a bitter war of succession that some referred to as the nineteen long winters and the Anglo-Saxon Chronicle described as a time when 'men said openly that Christ and

King Stephen's Chair. Did a medieval monarch rest on it during a bitter civil war?

His saints slept'. The garrison of the Hereford Castle were loyal to Stephen, who spent Whitsun in the city and heard Mass in the cathedral. A medieval chair near the high altar is referred to as King Stephen's Chair. In 1139 the castle was under siege by Matilda's supporters, led by Geoffrey Talbot and Miles of Gloucester. Their troops erected a catapult on the cathedral tower to bombard the castle, and the interior of the religious building was used as a stable. Even worse, earthworks were dug through the burial ground and the corpses, both long decomposed and those recently buried, were left exposed on the earth. Eventually the castle surrendered and Miles was created earl of Hereford.

The First Charter

Fortunately for Hereford, by 1189 Richard I was seriously short of money to pay for his crusade, so in return for some cash, he granted Hereford a city charter, giving its citizens extensive trading rights and privileges under the control of an annually elected bailiff. In 1383 the bailiff's status was raised to mayor, elected annually at 'Lukestide' (18 October).

Bishop Giles de Broase

Bishop from 1200–15, Giles's father, William, was one of King John's most prominent Marcher Lords but, as suspicions grew that John had killed his nephew Arthur, William's wife Maud refused to send her own son William to John as a hostage and John turned against the family, determined to destroy them. Maud and her son were imprisoned in the

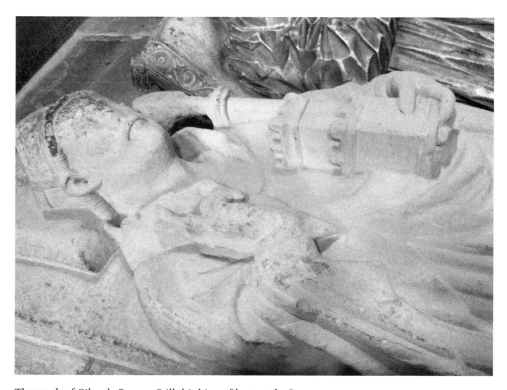

The tomb of Giles de Broase. Still thinking of lost castles?

Tower of London and starved to death and William senior was deprived of all his lands and forced into exile and poverty. After his father's death Giles tried to regain his family's castles but John demanded an exorbitant sum of money in return and still did not make good on his promise. While Giles kept his position he was forced to act as a witness to a charter that deprived his widowed sister of her inheritance. Inevitably Giles became the only bishop to support the barons' rebellion against John and opened negotiations with the king prior to the famous meeting at Runnymede that led to Magna Carta. It was at this earlier meeting that the clause that none should be arrested except by the law of the land and judgement by their peers was first mentioned and may have been the work of Giles. Perhaps thanks to his work Hereford Cathedral has an original copy of Magna Carta, dated to 1217. Worn out by all this strife Giles died in the same year as John. His tomb, rather sadly, shows him cuddling a castle in his hands, although some believe this is a reference to the cathedral tower, which was built in his time.

A Good Death

There was nothing the medieval mind feared more than sudden death, which might send a soul straight to hell, so if a death was considered imminent, a priest would be sent for. The priest would take the reserved sacrament in a solemn procession through the streets to the dying person's house, with an assistant walking ahead with a lighted candle to represent Christ's presence and ringing a bell to alert people to show proper reverence. On entering

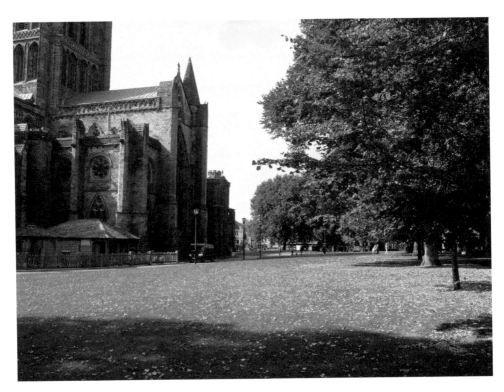

The Cathedral Close, the site of bitter disagreements.

the house the priest would sprinkle the dying person with holy water, hold a cross aloft to give comfort and drive any demons away and give absolution. After death the body was stripped, washed and put in a shroud. It was normal to keep the body in the house overnight. The next day the body was placed in a reusable coffin, owned by the parish, and taken to the cathedral in a formal procession. At its head would be a man ringing a bell, followed a man carrying an unlighted taper. They would be followed by the cross bearer and another taperer. After these came two robed clergy, walking backwards, one carrying a prayer book and the other holy water to sprinkle the road. Next came the bier with four bearers, the coffin covered in a black cloth, followed by another taperer and finally the mourners. On reaching the cathedral the Office of the Dead would take place and the body could be buried. The candles were kept by the cathedral as part of the funeral dues. The burial had to follow certain rules to ensure physical resurrection on Judgement Day so the Church had to take it seriously and irregularities would be reported. In 1397 these included the stealing of corpses from other parishes, corpses buried without mass, refusal to carry out a burial without a valid reason and a vicar cursing the body of one John Boley as he laid it to rest. Since Christ would appear from the east bodies were normally buried west-east so they would be facing the risen Christ. Most graves were unmarked other than by temporary wooden markers. While the rich could afford to be buried in the cathedral, or to the east, closer to the altar, excavations in the close show that the west side was used for mass burials. The north was reserved for excommunicates, suicides and others of dubious status.

The Jewish Quarter

In the Middle Ages Christians were not allowed to charge interest on loans, which put a bit of a dampener on the economy. Fortunately a solution was found with the Jewish community, who arrived in Hereford in 1179 and had become so established by 1194 that they were able to make a substantial contribution to the ransom for Richard the Lionheart

Maylord Street, Jewish Quarter in the medieval period.

after he was captured returning from the Third Crusade. Given the sometimes uneasy relationship with the townspeople to whom they lent money, they kept together in their own community centred around Maylord Street, at least until all Jews were expelled from England in 1290 after the money owed by the Crown became too large to service. In July of that year a royal decree ordered all Jews to quit the country by the beginning of November, but that they should suffer no harm during their departure and their property should be fairly valued and paid for. They would not be allowed back until the Protectorate of Oliver Cromwell. The medieval Jewish cemetery is thought to have been at the rear of St Giles' Hospital, which was at the corner of St Owens Street and Ledbury Road.

Hereford Castle

Although probably one of the earliest motte-and-bailey castles in England, it was not until the reign of Henry III that the timber building was replaced by stone, as the political situation with Wales became more problematical. Given Henry's success in Wales and the increase in English castles being built in the principality, Hereford soon became more a centre of war supplies than a front-line castle. It suffered from being a royal possession where the monarch felt no need to spend a lot of money and so was consequently often described as in a state of disrepair. John Leland, a travel writer in 1540, notes its poor state, although he does describe it as 'of as great a circuit as Windsor'. Its greatest military test might have arrived in the Civil War, but by then artillery had made medieval castles obsolete. Castles,

The site of Hereford Castle, once a mighty castle before the stone was reused by the citizens of Hereford.

Castle Cliffe, the last surviving castle building.

Castle Pool, the last remnants of the castle moat.

symbols of aristocratic oppression, were being destroyed all over the country during the Protectorate and Hereford became no exception. In May 1659 the order came from London to demolish the great tower, then one of the best preserved parts of the castle, but a source of valuable building material. The citizens of Hereford did such a good job that the site of the tower is now lower than the original bailey, which now forms the Castle Green. The only medieval building still standing is Castle Cliffe, on the lane that links the green with Quay Street. Once the governor's lodge, then a prison, it is now a well-located B & B.

DID YOU KNOW?
For a few months in 1265 Hereford was the virtual capital of England, with both Henry III and his son the Prince of Wales imprisoned in the castle and the de facto ruler of the country Simon de Montfort using the city as his base to attack the troublesome Marcher Lords. However, his power was unstable and would not last.

Simon de Montfort

When the barons rebelled against King John's son, Henry III, in 1264 they chose Simon de Montfort as their leader, with the aim of curbing the king's powers. Given Henry's unpopularity over his expensive Welsh campaigns and the foreign bishop he had imposed on them, Hereford's leading citizens decided to side with the rebels. This was a brave move as one of the king's leading supporters, Roger Mortimer, was based at nearby Wigmore Castle. Roger's forces were not strong enough to take the city but he was able to burn the suburbs that had grown up around the south and east of Hereford.

Events seemed to be going Simon's way. He captured both the king and his eldest son, Edward (the future Edward I), at the Battle of Lewes. Edward was brought to Hereford Castle for safekeeping, but you cannot keep a prince you are trying to negotiate with in a dungeon, so Edward was allowed some freedom, including exercising his horse. One day, while riding at the Widemarsh, he suggested a series of races to see who had the fastest horse. In a short while all the other horses were exhausted and Edward, who had not indulged in the racing, suddenly galloped off and the other tired riders could not catch him. He made his way to Wigmore and from there set about raising an army loyal to the king. A more dynamic leader than his father, Edward was a serious challenge to Simon. Leaving his base in Hereford, de Montfort met the prince's army at Evesham, where he was defeated and killed. Hereford was fined 500 marks for daring to support the rebels, but the king did pay compensation for the destruction caused by Mortimer.

The Wye Bridge

Since Hereford owes its existence to its convenient ford, it was inevitable that a bridge would eventually be built to make the crossing easier. There was probably a timber structure in Saxon times but it was replaced with a stone construction shortly before the

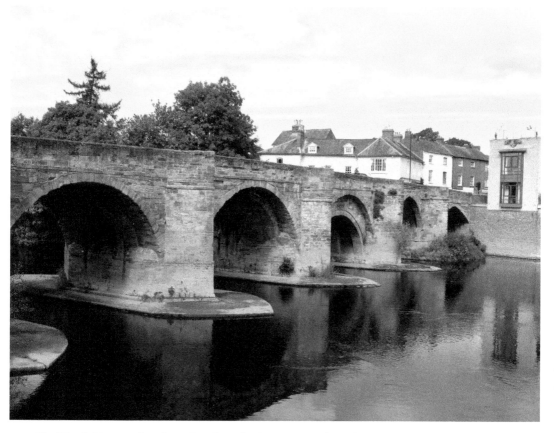

The Wye Bridge was for a long time the only river crossing for miles.

Norman Conquest. It was naturally defensible, with a gate on the southern side. It was only put to the test during the Civil War, when the Scottish army of Lord Leven laid siege to the city. Such was the amount of cannon shot they devoted to the bridge gate that it was rendered useless so the decision was taken to break down one of the arches of the bridge and form a barricade behind it.

For centuries the bridge remained the only river crossing for miles but, after the Second World War, with increasing road traffic (in 1965 a study found more than 24,000 vehicles crossing per day), the decision was taken to build a new bridge as part of a new ring road and Greyfriars Bridge was opened in 1967 to take the pressure off the old structure.

Bishop d'Aquablanca

The most unpleasant man ever to be appointed to the Bishopric of Hereford, he had arrived in England with Henry III's Savoy wife Eleanor of Provence. He spoke no English, was very fat and had a vile temper. He was hated by the canons of the cathedral and other clergy because he appointed his own relatives to every office that he controlled and one chronicler, Matthew Paris, said 'his memory exhaled a sulphurous stench'. One

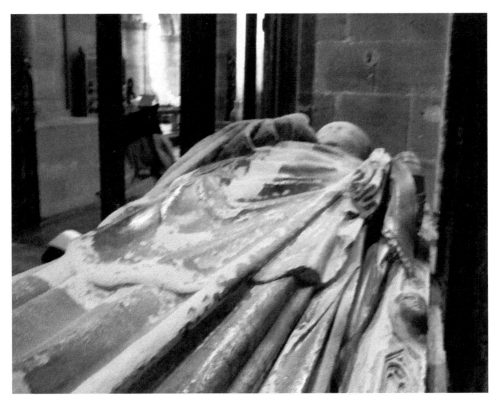

The tomb of Peter d'Aquablanca. Was he the worst bishop ever?

early ballad about Robin Hood depicts him getting the better of an arrogant Bishop of Hereford and it is generally thought that it was Peter d'Aquablanca who was the model for this. Such was the hatred d'Aquablanca generated that, in 1252, his chaplain Bernard was murdered while saying Mass in the Bishop's Chapel. In 1262 a major riot broke out in the city, with armed townsmen putting a barricade around the close and preventing the bishop and his staff leaving or receiving food until the bishop agreed to negotiate. During the unpleasantness between Henry III and Simon de Montfort he was seen as a crony of the king and was imprisoned for a while in Eardisley Castle. He died soon afterwards. The pope made the unruly canons pay for his tomb in the north transept of the cathedral, which he had been responsible for rebuilding.

The Excommunicate Saint
Medieval bishops could not afford to be unworldly priests but were important landowners who had to protect their rights and powers. Thomas Cantilupe, who became Bishop of Hereford in 1275, was so determined to protect the land and income of the Church that he fell out with many people, including Gilbert de Clare, the 'Red Earl' of Gloucester. Then he went a step too far and got into a bitter row with the Archbishop of Canterbury, who excommunicated him. Thomas was forced to make the arduous journey to Rome to clear his name but unfortunately died in Italy. His body was boiled so that his bones could return to Hereford. Within a few days of his burial a series of miracles were reported at his

tomb, which prompted the dean and chapter of the cathedral to ask the pope to canonise Thomas. One of the most astonishing miracles examined by the papal commissioners was that of William Cragh, or William the Scabby, a Welsh rebel accused of murdering thirteen men and hanged by William de Broase, Lord of Gower, at Swansea. However,

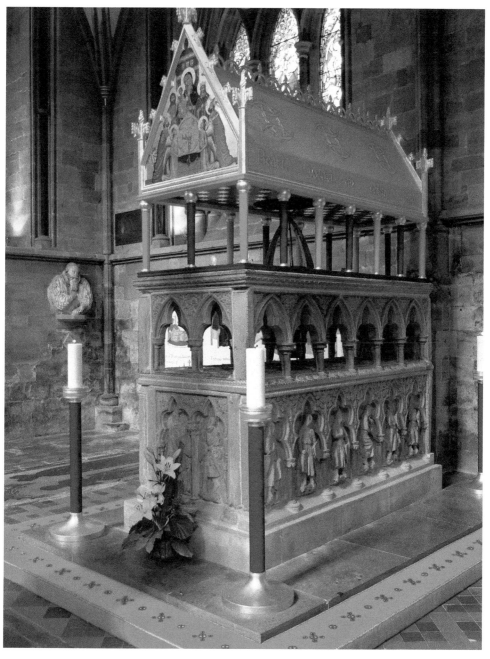

The shrine of St Thomas Cantilupe. This is a modern replica of the magnificent medieval original. (Courtesy of Phill Lister under Creative Commons 2.0)

de Broase's wife prayed to the recently deceased bishop and, a day after his hanging, Cragh showed signs of life and made a full recovery in a couple of weeks and was eventually able to make a pilgrimage to Hereford to give thanks for his resurrection, together with de Broase and his wife. The story was so odd that the investigating committee decided not to include it in the list of agreed miracles but there were enough for Thomas's sainthood to be considered. There are now plans to set up a series of hiking paths between Swansea and Hereford to commemorate the pilgrimage. A lengthy series of meetings took place to try to determine if Thomas had died excommunicate and eventually it was decided that he had not and could be declared a saint. This was good news for the cathedral as the shrine of St Thomas of Hereford became almost as popular as St Thomas Becket of Canterbury. Much of the magnificence you see around you when you visit the cathedral was paid for by pilgrims to St Thomas. The story goes that, as the Reformation became more vicious, the cathedral authorities became worried about the saint's fate and secretly parcelled up the bones and distributed them to notable Catholic families for safekeeping, who were to eventually return when conditions were right. However, they never were and the custodians changed allegiance or, over time, the significance of the bones was forgotten or they were lost, so few, if any, of the bones have been returned. Although the tomb was damaged during the Reformation, it has recently been restored and modern visitors to the cathedral can now get an idea of its original magnificence.

Monopoly on Burials

Throughout the medieval period all burials in Hereford had to take place in the cathedral cemetery, a valuable revenue stream. Naturally this caused resentment among parishioners of outlying churches and their rectors, who were deprived of any income from deaths for themselves. In 1346 it was discovered that burials had taken place at Allensmore and Bishop Trilleck ordered the offending bodies be exhumed and reburied properly at the cathedral.

City Walls

Although motorists might not agree with the idea, Hereford is fortunate in preserving its medieval street plan, which gives it an old world charm. The chief glory of this is the remarkably well preserved city wall, dating from the end of the thirteenth century, when Hereford had much to fear from marauding Welshmen. Although town planners of the sixties are often rightly criticised for some crass decisions, in making the line of the city wall the route of the inner ring road they gave the wall more prominence than it had been given for many centuries and preserved the small market town character of the city.

Mappa Mundi

The greatest of Hereford Cathedral's treasures, this is a map of the known world in around 1300, when it is thought to have been created, with Jerusalem at the centre, and is the largest medieval map in existence. Probably the work of more than one hand, studies of the wooden frame shows that it originated in Hereford.

For many years it hung, virtually unregarded, in the north choir aisle, but, in 1988, the dean and chapter proposed selling the map to pay for urgent repairs to the cathedral. On the basis of you don't know what you treasure until you risk losing it there was a public outcry. In the end it was saved by public donation as well as generous grants from the National Heritage Memorial Fund and Paul Getty and is now well presented in a purpose-built exhibition space that also houses the Chained Library, one of the largest collections of pre-1500 books in the world, and the only one to survive with all its chains, rods and locks still intact. The collection includes a priceless Hereford Gospels dating from 780, the only book to survive the Welsh destruction of 1055. The museum also includes the collection of pre-1500 books from nearby All Saints Church, which was also one of the largest in the country.

The Boy Bishop
One of the ancient customs of the cathedral, which has recently been revived, is the installation of a boy bishop, who is chosen from amongst the choristers, on 6 December, the feast day of St Nicholas, the patron saint of children. Through the season of Advent the boy bishop wears full ecclesiastical vestments and takes part in services. Such role reversal, where masters and servants swap roles, was a common part of medieval Christmas festivities, as a social safety valve when other forms of protest were difficult, were often abandoned after the Reformation but this particular custom was revived at Hereford Cathedral in the 1970s.

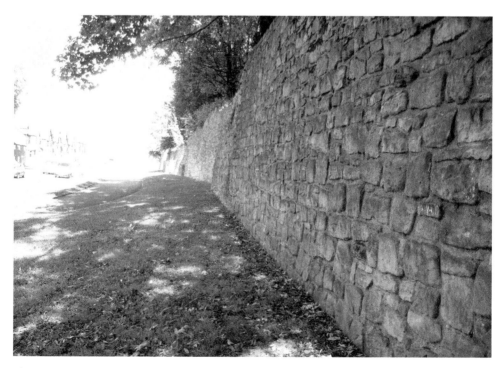

The city walls, one of the best-preserved medieval walls in the country.

The Mappa Mundi Exhibition Centre. It now houses the Chained Library and a wonderful interpretation of the medieval map.

St Peter's Church

Though much 'renovated' in the nineteenth century, St Peter's was founded in the eleventh century. Its beginnings were not auspicious. The man who was paying for the building, Walter de Lacy, climbed up the tower early one December morning to see how work was progressing, slipped on some ice and fell to his death. Even so it is the civic church of the city, where municipal ceremonies are conducted, either in the church or in the square outside. Moving with the times its old pews have been taken out to make an innovative meeting space.

All Saints

The church has a commanding position at the top of Broad Street. Its origins go back at least to the thirteenth century, when there was a building boom for churches in the area. Once noted for its twisted spire, when the church had to close in 1996 for major repairs the spire had to be straightened but the opportunity was taken to provide space for a very popular café to the rear of the nave. Of special note are the carved misericords in the choir and, high on wall of the upper floor of the café, an X-rated carving of a monk, who must have done something to annoy the carpenter.

St Peter's Church, the civic church of Hereford.

All Saints Church, now with its straightened spire.

St Ethelbert's Fair

Held over nine days in May, the right to hold a fair had been granted to the bishop by Henry I in 1121 and was an important source of revenue for the church as well as attracting pilgrims and traders to the city, although another area of grievance to the populace as all normal commercial activity had to cease while the fair was in operation. Over time it became more of a pleasure fair than a trading event and, because of the disturbances that it caused, in 1838 it was agreed to reduce it to just three days. The fair is still held in the streets of Hereford when the narrow streets of Hereford are filled with giant waltzers and the smell of hot dogs and shop managers complain of the loss of trade that this disruption causes, unconsciously mirroring the views of shopkeepers of the past.

John Le Gaunter

Six times mayor of Hereford, at the end of the thirteenth century he collected together all the ancient customs and rules of the city. He did this, not out of any interest in history, but so he could sell the practices to the many new boroughs that were being founded, especially in south Wales and who were looking for some boilerplate constitutions to help them get started. In 1284, when Cardiff burgesses applied for a copy of Hereford's customs they were curtly reminded that the town 'was not of our condition' and could only have the laws and customs by purchase.

In the Event of a Siege

Such was the likelihood of trouble from the Welsh border that Hereford's Custom Book of 1286 set out what to do in the event of a siege:

> When our city shall be besieged by the Welshmen, or by enemies of our lord the king, our chief bailiff shall cause to be proclaimed that everyone, of what condition so ever he be, which both dwell in the city ... that they be ready, as well by night as by day, to the protection of the city, and to watch and ward when they shall be warned by the constables. Also that no one, of whatever condition he be, shall hide, or cause to be hid, any armour or manual weapons, but shall deliver such to the constables.
>
> One bell we use to have in a public place... to give warning of all men living within the city and suburbs ... all manner of men abiding within the city, suburbs and liberties, of what degree so ever they be, ought to come at such ringing, or motion of ringing, armed with such weapons as fit their degree: and it shall be commanded or told them by our chief bailiff, on behalf of our lord the king, what is to be done for the preservation and tranquillity of the city.

The Preaching Cross

The medieval Church was not a monolithic structure but made up of different groups and orders, which could lead to some tension. Franciscan friars, the Grey Friars, arrived in Hereford in 1228 and got along reasonably well with the cathedral authorities but it was

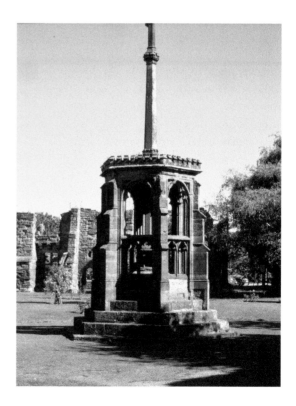

The Preaching Cross, where the Blackfriars preached the word of God.

the arrival of the Dominicans, the Black Friars, in 1246 that caused things to go downhill. Originally granted land in the Portfield near St Owen's Gate, the Dominicans proved charismatic preachers who threatened to divert money away from the cathedral. Bishop d'Aquablanca and the Franciscans took action. In 1253 some thugs invaded the friary, dragged the inmates to a nearby field and set fire to the building, completely destroying it. In 1319 Edward II granted them land on Widemarsh Street. Under royal protection they were able to build a substantial priory, which lasted until the Dissolution of the Monasteries. One important remainder is the preaching cross in what was the friars' cemetery, now the only surviving example of a friars' preaching cross in England.

Adam Orleton

One of the few bishops of Hereford likely to have been born in Herefordshire, Adam may well have been born in the village of Orleton in north Herefordshire, in the ancestral lands of the Mortimers of Wigmore. Roger Mortimer, whom he may have known as a child, was to play a pivotal part in his future.

His early career was in Paris, where he was closely involved in the suppression of the Knights Templar by Philip IV. He was appointed Bishop of Hereford in 1317 on the order of the pope and against the wishes of Edward II. The king's fears were well founded because Bishop Adam played a major role in Edward's overthrow by Roger Mortimer. There has been some suggestion that, given rumours that had been attached to the Templars, it was he who came with the idea of accusing the king of sodomy and even the method by which Edward was may have been murdered, involving a red-hot poker.

Surprisingly, with the fall and execution of Mortimer, Adam retained the favour of Edward III and was promoted to Bishop of Worcester and later Bishop of Winchester.

Despite his involvement in national politics, Adam was remembered in Hereford as a conscientious bishop, reforming various abbeys and priories that had previously been allowed to fall into scandalous ways.

High Town

Now a peaceful place where people can drink coffee or buy artisanal food, High Town was the scene of two grisly executions. The first was in 1317, when Hugh Despenser, the hated favourite of Edward II, was captured in Wales and taken to Hereford to face the justice of Edward's vengeful queen Isabella and her lover Roger Mortimer. The sentence could not be more horrible. Tied to a hurdle, he was dragged to High Town and hanged on a gallows 50 feet high. Still alive he was cut down and his entrails slowly pulled out and then finally beheaded and his remains cut into quarters. Meanwhile Isabella and Roger watched the events from a nearby stand while feasting with their supporters. People had stronger stomachs in those days.

The second took place during the Wars of the Roses. In 1461 Owen Tudor, who had married the widow of Henry V, was captured at the Battle of Mortimer's Cross. Being a man of rank he expected to be ransomed but this was a civil war and had turned nasty. It was only when he arrived in High Town and saw the executioner's block waiting for him that he realised his time had come. His last words were reported to be, 'The head

High Town was the scene of several grisly medieval executions.

that was wont to lie in Queen Catherine's lap will soon lie in a basket.' It was after his head had been cut off that things turned strange. A woman came forward to take charge of the head, washed it and placed it on the market cross, surrounded by candles, and kept watch over it through the night. The flickering candlelight must have made the head an eerie sight. No one seems to have asked the woman who she was or what her purpose was so the truth will never be known, although some historians surmise she was Owen's current mistress.

The Black Death
The plague arrived in Hereford in the autumn of 1348. There is no good time to be visited by the plague but this was a particularly bad time for the city. In the winter of 1315–16 the harvest had failed after torrential rain, leading to famine. This was followed by the unrest caused by Roger Mortimer's rebellion against Edward II and the high taxes demanded by Edward III to fund his war with France. Bishop Trilleck faced a difficult test. In the years before he had been forced to act against some of his clergy for being slack and disrespectful. Now they faced a horrific test. By the end of 1349 fifty-five of the clergy had died as well as twelve resignations and eight-eight who seem to have simply run away. Excavations in the close in 1993 discovered three mass graves that might contain over 300 bodies, a tenth of the population. These are probably not the only plague pits and some

experts believe that the population fell to 1,000, through both death and flight. Contrary to popular imagination the bodies had not just been chucked in but laid neatly in rows. The pits were probably kept open for days as new corpses came from outlying areas, with the bodies being covered with a layer of earth at the end of each day in an effort to hide the stench and prevent infection. One long-term consequence was that arable farming declined and animal pasture increased because it was less labour intensive.

The White Cross

The plague returned to Hereford in 1361, causing the same panic and fear of thirteen years before. After the worst was over Bishop Charleton ordered a stone cross be erected on waste ground to the west of the city to give thanks for Hereford's deliverance. It replaced a simpler cross that had functioned as a temporary market, farmers from the countryside leaving their produce early in the morning, returning in the evening to collect the payment that had been left in strongboxes filled with holy water and blest by priests as a double insurance that the coins were not infected. Whatever the efficacy of the blessing the process did prevent the large crowds that markets normally attract and the people of Hereford did not starve.

The White Cross commemorates the terrible deaths caused in the city by several outbreaks of the plague.

Wild West City

By 1377 Hereford had a population of 2,850 and was a prosperous trading centre in corn, leather and especially wool, that of Herefordshire being considered the best in the country.

However, not everything was going well. In 1383 the Wye Bridge was in such a bad state of repair that it was considered a hazard to anyone crossing it. Hereford also suffered from being near the Welsh border and the constant fear of raids. Things became especially fraught after the Owen Glyndwr rebellion of 1400–15, after which an act of parliament forbade any Welshman from holding land in the city.

Owen Glyndwr

Glyndwr's rebellion against Henry IV, which came very close to succeeding, started very badly for the men of Hereford, when a great number of them were massacred at the Battle of Pilleth on the Radnorshire border and gave the Welsh free rein to plunder Herefordshire. The king sent his son, the future Henry V, to deal with the situation and the young man chose Hereford as his base. Success swung from side to side: improved tactics by Henry forced the Welsh back but French reinforcements for Owen allowed him to once more invade, though fortunately passing to the south of Hereford, and advance as far as Worcester before being forced to retreat. Eventually Owen's supporters fell away and Herefordians could sleep more easily in their beds.

Sir Richard Pembridge

The magnificent monument of a knight in the nave of the cathedral is that of Sir Richard Pembridge, who fought in three of the major battles of the Hundred Years' War, Sluys

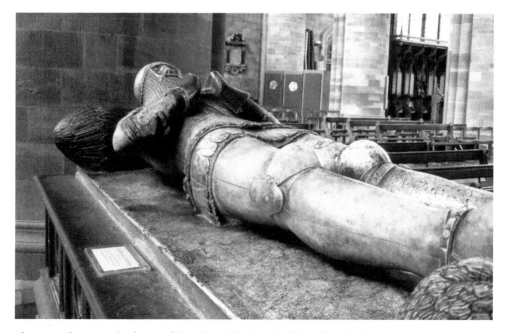

The magnificent tomb of powerful medieval knight Sir Richard Pembridge.

(1340), Crecy (1346) and Poitiers (1356). Given such an impressive military record it is little wonder that he was made one of the earliest Knights of the Garter. He was well regarded by Edward III and his son the Black Prince but, in 1372, refused to take up the post of Lieutenant of Ireland and was still in disgrace from court when he died in 1375, the king thinking him ungrateful. The site of the tomb, to the south of the nave, was chosen by Sir Richard himself, as he was determined to be buried in the cathedral. Like most of the monuments it has suffered some serious damage, partly the result of religious fanatics but also, in Sir Richard's case, the result of the collapse of the West Tower in 1786, which covered it in debris. Well-meaning Victorian restorers tried to replace his damaged legs but put his garter ribbon on the wrong one. He lies for eternity with his faithful hound at his feet and resting his head on his great helm. That helm, which used to hang above his tomb, is still in existence and can be seen at the National Museum of Scotland in Edinburgh.

The Booth Hall

In 1392 Henry Catchpole, a rich wool merchant, gave his house, the Booth Hall on the south side of High Town, to the burgesses as a place to hold their meetings, though the current building dates from the end of the fifteenth century, when much of the city was remodelled. Behind it was built a Freeman's Prison to house any freemen of the city who

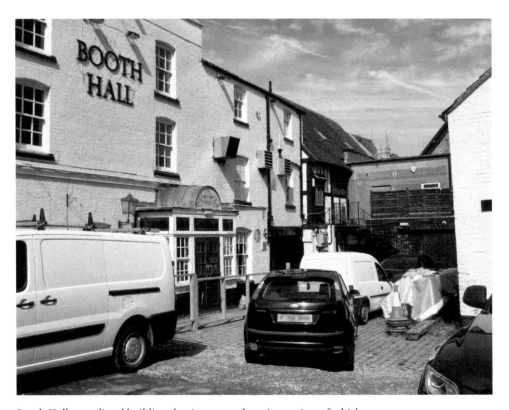

Booth Hall, a medieval building that is now undergoing major refurbishment.

were suspected of crimes to save them the indignity of being sent to the Bridewell with the common people. By the end of the seventeenth century it had come down a bit in status to that of an inn noted for its cockfighting. The most famous landlord was Tom Spring, the prize-fighting champion of all England in the early nineteenth century. In 1919 a chimneystack fell, which had the positive effect of exposing a magnificent medieval roof that had been covered up when the building had been transformed into an inn and smaller rooms were required. In the twenty first century the Booth Hall suffered two further setbacks. A fire in 2010 destroyed the front of the building and arguments over ownership meant that it has not been repaired. Changing drinking habits have also meant that pubs face a difficult future and the Booth Hall is currently closed and its medieval timber unavailable to the public.

DID YOU KNOW?
There was, very briefly, a Duke of Hereford. The title was created for Henry Bolingbroke, who was already Earl of Hereford, by his cousin Richard II in 1397, in recognition of Henry's support against their uncle the Duke of Gloucester. Two years later Henry got a better title, that of king (Henry IV), having overthrown Richard.

Civic Disputes

Inevitably, and despite civic leaders attempting to exert as much authority as they could, the semi-independent Marcher Lords had a great deal of influence in the running of the city, especially the Mortimers of Wigmore and the Talbots of Goodrich. The church also had more say than the civic authorities would have liked. Bishops of Hereford claimed various rights that the citizens believed infringed their charters. Things became so fractious at the end of the fourteenth century that clerical officials, including the dean, were physically assaulted. Many of the disputes centred around the Cathedral Close, which the church wanted to keep a sacred place but the citizens felt they had a right to use for their own purposes. In 1389 Richard II granted the dean and chapter the right to enclose the cemetery and keep it locked at night to prevent sacrilegious acts such as theft of church goods, burial of unbaptised babies and pigs digging up bodies as they scavenged for food among the graves. This did not prevent the people of Hereford using the close in daytime and, in 1434, Bishop Spofford was complaining that the beauty of the cathedral was being marred by unseemly trading and the close resembling a highway rather than a holy place dedicated to God. In an attempt at a show of unity processions were organised for Feast Days around the Close where church and city could walk together but they did not always go as planned, with each party vying for superiority. On one occasion an official of the mayor was so incensed by the dean's officers pushing in behind the dean and in front of the mayor that he hit one of the dean's men with his staff, causing the man to fall forward and hit the dean on the back of his head.

Thuggish MPs

Hereford has sent representatives to Parliament since the time of Edward I but some of them were quite a rowdy lot. Thomas Buryton was alleged to have assaulted the dean of Hereford, John Orchard broke into and stole from the cathedral and John Abrahall was implicated in two murders and led a gang of thugs in looting, larceny, horse stealing and abduction. Henry VI, writing to the pope, described the people of Herefordshire as wild and untameable by nature.

The Wars of the Roses

At this time whom you supported was not like a referendum, where you sat down with the facts and made a rational decision. You supported whomever your feudal lord supported and his decision depended on his lord, so on up the chain until you came to the great magnates who could decide for themselves where their best options lay. Hereford was principally Yorkist, Richard of York having inherited the sizeable landholdings of the Mortimers of Wigmore. In order to demonstrate the poor governance of Henry VI, York orchestrated demonstrations in various English towns, including Hereford, where the 'Welshmen', recent arrivals, clashed with the established burgesses, who were suspected of Lancastrian sympathies. In 1448 the 'Welshmen' invaded St Peter's Church to prevent a new mayor being appointed, leaving a trail of destruction behind them.

After the Battle of Mortimer's Cross in 1461 there is a legend that both the victor, Edward, Earl of March, and the captured Owen Tudor spent the night at an inn on the site of the present Green Dragon, talking over the events of the day into the small hours, Owen unaware of what Edward planned for him the following day.

After he became king Edward, to show his appreciation of the help the city had given him, made a royal progress to the city. The Council of the Marches was established in Hereford to govern the troublesome border but, because of the poor state of the castle, it soon moved to Ludlow.

4. The Sixteenth Century: Hereford Loses Some of Its Importance

By the early part of the century Hereford was a flourishing market for the produce of the surrounding countryside, noted for its arable and orchard crops but especially the renowned Herefordshire wool, with a population of around 4,000. Cloth making flourished, although was badly damaged in 1526 then the Crown ordered the destruction of fulling mills outside the city, which created considerable unemployment.

Conflict in the Close

In October 1519 a fight broke out between a canon, Nicholas Wallue, and a local man called William Hill. The canon grabbed Hill, hit him with his fist, called him a knave and a whoreson and then took Hill's pint pot and hit him over the head with it, causing blood to be shed and so desecrating the close. The mayor, Nicholas Hayes, took advantage of this to say that, now the cemetery had been desecrated, he and his men could now lawfully break the heads of others within the close, as cathedral law no longer applied to

The Cathedral Close is now peaceful but was once the scene of bitter disputes between the church and civic authorities.

it and the mayor could take control if necessary. The bishop quickly held a ceremony to reconsecrate the space.

Fiercely Independent

Throughout the period there continued to be tension between the civic authorities and the bishop over their respective rights and privileges, with various bishops complaining about the way their officials had been manhandled while going about their business. Hereford dignitaries were strongly protective of their powers and in this they were helped by there being no resident peer in the city who might attempt to control them. Even when the mighty Earl of Essex tried, in 1597, to appoint his own MPs for the borough rather than those chosen by the freemen, he was quickly disabused of his power to do so by the mayor and corporation.

The Black Lion

The oldest existing pub in Hereford, having been built in 1575, in a room on the first floor there are some wall paintings from that period depicting the breaking of the Ten Commandments, whether as a warning or advice we cannot be sure. It is also said to be the most haunted building in the city.

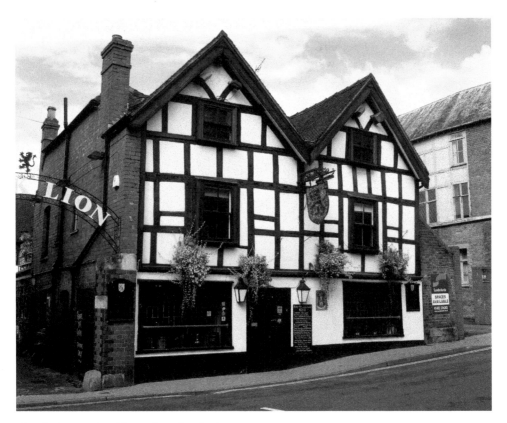

The Black Lion, the oldest pub in Hereford.

Hereford once had the finest wooden building in Europe. At the cusp of the sixteenth/seventeenth century Hereford was noted for the brilliance of its woodcarvers and the greatest of their achievements was the Market Hall that once stood in High Town. Built in 1576, of three storeys and supported by twenty-seven walnut pillars, the first floor was reserved for the city magistrates and the second meeting rooms for the fourteen craft guilds of Hereford. It rivalled any of the fine structures that can still be found in Europe. The open ground floor provided space for a market. Once the centre of civic pride, described by Nehamiah Wharton in 1642 as the 'stateliest in the kingdom', by the middle of the eighteenth century it had fallen into disrepair and the decision was taken to remove the upper floor and turn it into a drab classical building. Few liked the result and, in 1861, the whole building was demolished. The process might be considered short-sighted vandalism.

Alexander and Ann Denton

Perhaps the finest memorial in the cathedral is the one dedicated to this couple, which is made of alabaster and still retaining much of its original colour. Alexander looks very imposing in his Elizabethan armour, but it is the figure of his young wife who draws the attention. She died in childbirth at the age of seventeen, and hidden in the folds of her skirt lies the body of her new-born child, still in its swaddling bands. In fact only Ann and her child are actually buried here. Alexander remarried and was laid to rest with his second wife in Buckinghamshire.

DID YOU KNOW?
A Bishop of Hereford wrote one of the first books of science fiction. Francis Godwin, Bishop of Hereford from 1616 to 1633, wrote *The Man in the Moon* towards the end of his life, although it was not published until after his death. It purports to be the travel notes of Domingo Gonzales, who harnesses large swans to a basket, which enables him to travel to the moon, a journey that takes him twelve days. There he encounters a lunar society that is Christian and in many respects better than that in Europe. However,, because he is homesick and worried about the condition of his swans, he decides to return to earth.

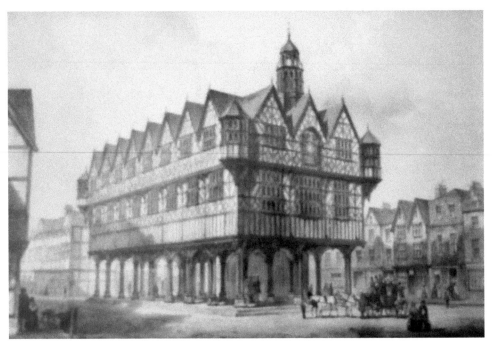

An old print of the Guildhall.

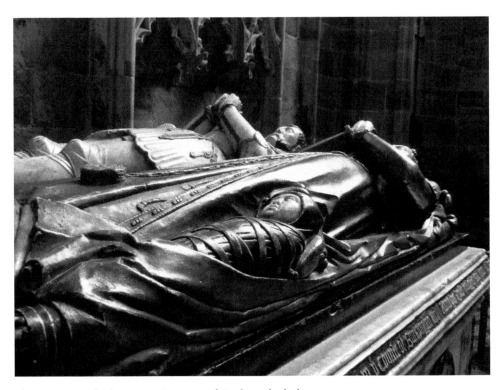

The Denton Tomb, the most poignant tomb in the cathedral.

Friars' Gate.

Eign Gate.

Widemarsh Gate.

Bye Street Gate, also known as Bysters' Gate.

St Owen's Gate.

5. The Seventeenth Century:
A Time of Bitter Disputes
That Brought Misery to the City

The late sixteenth century had been a period of severe economic hardship and, in 1603, the corporation complained that, 'merchandise and trade is decayed amongst us and the endeavours of the greatest part and chiefest of our city are converted to husbandry, malting and other occupations unfit to sustain the credit of so ancient a city'. Because of this there was little suburban expansion beyond the medieval city.

Disagreements
Passions in civic politics ran high in this period as they do now. One man named Sheward, a draper, was accused of breaking into the mayor's house late at night when drunk. When brought before the mayor the following morning he was unrepentant and declared, 'I care not for thee. I am as good as thee every day of the week. Thou wast a cook and scullion before and when thine office is ended thou will be a cook again; thou art a briber and dost live by bribes.' For such speaking truth to power he was deprived of his franchise.

Byster's Gate
The gate in the city walls to the north-east of the city, it was the most impressive of Hereford's gates, guarding the road from Worcester. It also served as the city gaol in the early modern period. Prisons of the period were notorious but this had a particularly fearsome reputation. In just a nine-month period during 1624–25 twelve of the prisoners were reported to have died, unusually high even for the time, though a jury found there were no suspicious circumstances, nine having died from God's visitation, one suicide, one drowned in the Wye and the last falling from the gallery of the Booth Hall.

During the Civil War it was this gate that the Parliamentarians took by stealth, a party disguised as workmen approaching the guard at dawn and then killing them with their spades, allowing the larger attacking force to gain entry.

Byster's Gate was demolished in 1798, the Pack Horse Inn that had stood next to it becoming the most dominant building. For many years it was owned by the Kerry family so it is only fair that the pub is now known as the Kerry Arms.

A Navigable River
During the Jacobean period the focus of Hereford Corporation was on obtaining parliamentary approval for the destruction of weirs and other obstructions on the Wye in order to improve trade and salmon fishing. This again brought it into conflict with the

The Kerry Arms is named after a former publican.

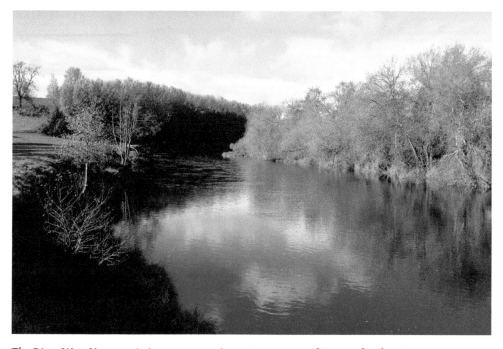

The River Wye. Now scenic, it was once an important source of income for the city.

bishop and other members of the gentry who had economic interests in the weirs and argued that they were necessary to power corn mills. The issue does not seem to have been satisfactorily resolved.

Coningsby Hospital

Following the Dissolution Blackfriars Priory was eventually acquired by Sir Thomas Coningsby of Hampton Court, north Herefordshire who set up an almshouse for twelve ex-soldiers on the site, distinguished as they walked around Hereford by their red coats. Known as Coningsby's Company of Old Servitors, a code was drawn up in 1716 to regulate their morals, they were old soldiers after all. These included Rule 9: any servitor who is convicted of cursing or swearing is to forfeit out of his weekly pay 1s. Bad enough but the penalty for being drunk was a whopping 2s 6d.

Tradition has it that Nell Gwynne was so impressed by this way of caring for old soldiers that she persuaded Charles II to set up a similar hospital for military pensioners in Chelsea.

The Gough Gang

In the early seventeenth century clothes were not the wear and throwaway items they can be nowadays but precious commodities that regularly feature in wills as being worthy of passing on to loved ones. So a gang of women who made a speciality of stealing them

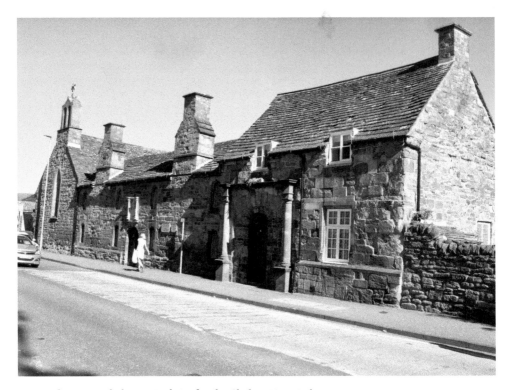

Coningsby Hospital, the original site for the Chelsea Hospital.

must have been a great source of worry to the law-abiding citizens of Hereford. Beatrice Gough seems to have been the ringleader. She admitted to stealing a Welsh yarn sheet and a smock petticoat from the garden of Gregory Ashbrooke near Byster's Gate, when they were drying on a hedge, and pawning them. In 1616 Richard Aston, a tailor, had a cloak stolen by Anne Gough, who fenced it at the house of a man called Rulins. Previously he had been accused of keeping a woman as a wife when his first wife was still alive. Making him to do penance in the cathedral for the offence seems to have had little effect on him as he was still living with this Katherine twenty-five years later.

In 1625 Margaret Balle was accused of stealing Thomas Adam's pig. She claimed that Beatrice Gough had brought the pig to Adams to sell but instead he grabbed it and she was put out of doors. In the early hours of the morning Beatrice had found the pig wandering the streets and had therefore taken it in. Beatrice was also accused of stealing washing hung out by Anne Bernard and a linen apron and waistcoat, the property of William Thomas, while it was drying, but she denied this. The Goughs and their associates must have been difficult neighbours.

The Old House

Once all of central Hereford looked like this half-timbered house but now the Old House is the only survivor. Built in 1621, it was originally part of a line of similar buildings known

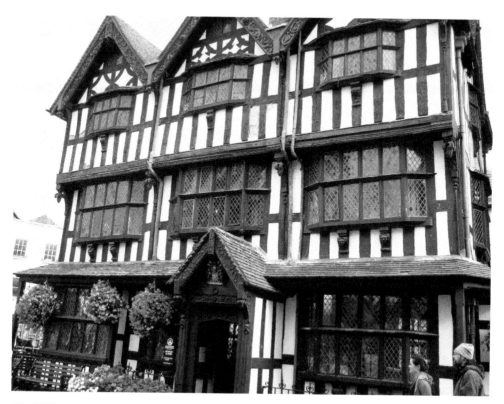

The Old House is now a museum on early town life.

as Butchers' Row. Sadly the other houses in the row were demolished in 1816 as part of a modernisation drive. After serving as a butcher's shop, an ironmongers and a bank, it has now retired to be a museum to the Jacobean period.

The Civil War

When hostilities broke out between the king and parliament most people just wanted to keep out of it, but there are always some fanatics who want to get involved and, in Hereford, the Royalist faction was in the majority. Things turned nasty in 1645 when a Scots army, fresh from victory at Marston Moor, laid siege to the city. It lasted throughout the month of August, creating misery for the townspeople, but then news reached the Scots that a large force led by the king was approaching and they were forced to retreat. It is thought they lost 1,200 men, compared to losses on the Royalist side of twenty-one. However, the war was not finished with Hereford. In December a surprise attack led by Colonel John Birch captured the city within half an hour and then took to plundering, plunging the city into an even greater state of misery. An uneasy peace lasted until the Restoration of 1660.

The Rowe Ditch is a medieval construction but was used by the Scots during their siege of the city.

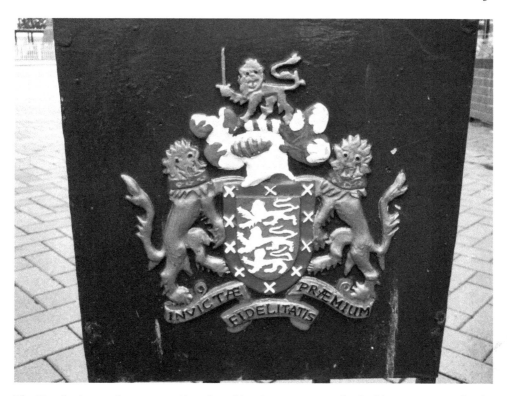

The Hereford coat of arms were given by a king in recognition of valuable service given by the citizens of Hereford.

DID YOU KNOW?
The coat of arms of the city of Hereford commemorates the siege of 1645. When Richard I gave the city its first charter he also granted it the right to a coat of arms, his own shield of a red field, differenced by three silver lions instead of the royal gold. No document supports this and it might be that city officials just decided to start using it. Charles I was so relieved that Hereford had stood up to the siege by the Scots, in a year that had mostly only brought him bad news, that he visited the city and augmented the existing shield with a blue border and ten white saltire crosses representing the Scots army. Unusually he also granted it the right to a peer's barred helm supporting the crest, a right only granted to one other city, the city of London. The Parliamentarians took the city in a surprise attack four months later.

Joyce Jeffries

One of the fullest accounts of what it was like to live in the city during these frightening times comes down to us from Joyce Jeffries, a prosperous woman with connections to the

powerful Coningsby family, who kept a diary in the period. She was on the side of the king and, as early as 1640, gave money to a collection to help him raise an army against the Scots. By 1642 relations between the king and parliament were deteriorating and Mrs Jeffries came upon soldiers practising with their muskets near her house, shooting out her window. Nevertheless she gave the man a shilling and some beer because he was on the right side. She later paid more money for weapons to strengthen the city's defences and to fit out her own soldier. As the Royalists prepared to make a stand, orchards and houses were levelled to aid the defence, including that of Mrs Jeffries. When a Parliamentary force entered the city, hers was one of the houses they plundered. 'They took away my two bay coach mares, much linen and Eliza Acton's (her godchild) clothes.' She survived all these privations but did not live to see the return of the monarchy, dying in 1653.

Nehemiah Wharton

A junior officer with the Parliamentary forces, he wrote a description of his impressions of the city while stationed here. He found the city walls very impressive and 'In the city there is the stateliest market-place in the kingdom, built with columns. The Minster in every way exceeds that of Worcester, but the city in circuit is not as large.' Wharton was less impressed with Herefordians. 'The inhabitants are totally ignorant in the ways of God and much addicted to drunkenness and other vice but principally in swearing, so that the children that have scarcely learned to speak do universally swear stoutly. Many here speak Welsh.' Wharton's regiment later fought at the Battle of Edgehill, the first pitched battle of the Civil War, but it is not known if he survived and no letters from him have been found after that time.

Sir Henry Lingen

The most notorious of Herefordshire Royalists, Lingen was from a long established gentry family and made High Sherriff of Herefordshire at the beginning of the Civil War with a commission from the king to raise a regiment of a thousand men. His rigorous methods of raising contributions to the royal cause made him few friends. Taking over the siege of Brampton Bryan Castle from Sir William Vavasour, he transformed what had been quite a civilised affair into something more deadly, using poisoned bullets and poisoning the stream that provided the castle with water. The only two fatalities on the defender's side were a cook hit by a poisoned bullet, who died in great torment, and a poor, aged and blind man killed by Lingen in the village street. Although the siege was unsuccessful, Lingen was personally knighted by Charles I for his devotion.

He was in Hereford when the city was surprised by Parliamentary forces but managed to escape over the frozen River Wye to nearby Goodrich Castle, where he carried out raids on Parliamentary forces and forced the local population to pay for the upkeep of his men. Eventually the Parliamentary commander John Birch had enough and laid siege to Goodrich but only managed to burn down the stables. During Birch's absence Lingen led a daring raid on Hereford, killing some of the garrison, but found the townspeople exhausted by the fighting and unwilling to help him keep the city, so was forced to return to Goodrich.

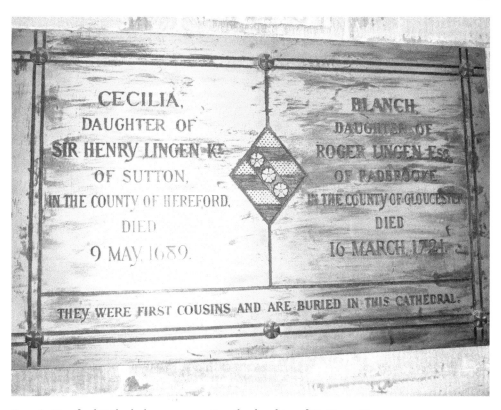

Brass in Hereford Cathedral commemorating the daughter of Sir Harry Lingen.

Birch renewed the siege and forced Lingen to surrender, although he was allowed full military honours, leaving the castle with flags flying and his band playing the tune 'Sir Harry Lingen's Fancy', the melody of which is now sadly lost. Confined to Hereford, he was still reported to be going about with his sword against the terms of his surrender.

The Restoration improved his prospects and he was elected one of the city's MPs, although this did not prevent a bitter dispute with another candidate, Westfaling, who had detained the mayor in the Guildhall. With his trumpeter sounding 'to horse' Lingen and his supporters charged to the mayor's rescue, trampling over men, women and children in the process. Returning from parliament in 1661 he caught smallpox in Gloucester and died at his house at Stoke Edith, so was not able to attain the success that the Restoration might have brought him.

Dean Croft

When the Parliamentarians took the city they had no respect for the sanctity of the cathedral and took to vandalising statues and monuments that they regarded as an affront to God. This so enraged the dean, Herbert Croft, that he preached a sermon condemning the vandalism. This in turn so enraged the soldiers that they levelled their muskets at him. His life was only saved by the intervention of the Parliamentary commander

The pulpit used by Dean Croft when he faced down Parliamentary soldiers.

Col. John Birch. He was, however, forced to give up his deanery but, after the Restoration, was appointed Bishop of Hereford and dean of the Chapel Royal in Windsor. Soon disillusioned with life at court, he spent most of his time in Hereford looking after the affairs of his diocese, a contrast to many past bishops.

Witch Hunt

In 1662 Richard Binns complained to the Hereford magistrates that his neighbour, Mary Hodges, an alehouse keeper, repeatedly swore and blasphemed and was running a brothel. More dangerously he also claimed that she had put a curse on him while he was shovelling muck for his father, caused his father's horse to die and bewitched his cattle. He also claimed to have seen her kneeling in her garden in the middle of the night making spells. This was a time when a successful accusation of witchcraft could get someone hanged and was being used throughout Europe as a way of settling scores, especially against the most marginalised of the population. Fortunately Mary Hodges was luckier than many. The magistrates deliberated and decided that she was nothing more than a common scold and bound her over to keep the peace.

Restoration Corruption

After the return of Charles II the townspeople of Hereford found that many of their previously strongly guarded powers had passed to the rural gentry. No Hereford resident

was elected an MP for the next forty years. By 1670 Paul Foley, who had bought the estate of Stoke Edith from the Lingen family, had taken firm control and the city revenues were alleged to have been diverted 'to the treating and entertaining Mr Foley and others of the same faction'. What that fervent Royalist Sir Henry Lingen would have thought about this strongly anti-court member taking over his estate is probably best not thought about. Foley was later accused of plotting to take over the Herefordshire militia and was placed under house arrest during the Monmouth rebellion. The Glorious Revolution of 1688, putting the Whig faction firmly in control, improved his fortunes.

Nell Gwynne

Although perhaps the most famous Herefordian, two other cities, Oxford and London, claim to be the site of her birth. She certainly was in London from her early teenage years and all her escapades took place there. However, there is a strong local tradition that she was born in Pipe Well Lane, a slum area close to the cathedral, which was renamed Gwynne Street in her honour in the nineteenth century. Her father might have been Thomas Guine, a captain of the Royalist cause from an ancient Welsh family who had fallen on hard times during the interregnum. Although nowadays best remembered for her relationship with Charles II, she was the best comic actor of her generation. In a twist that no fiction writer would dare make up her grandson, Lord James Beauclerk, was appointed the Bishop of Hereford in 1746, living in splendour yards from where his grandmother was born into squalor.

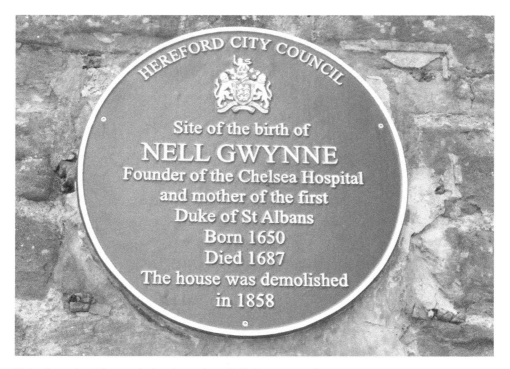

This plaque is said to mark the place where Nell Gwynne was born.

Thomas Treherne

The mystic poet was born in Hereford in 1637, the son of a prosperous shoemaker who may have become impoverished during the Civil War but was still able to send his son to the local cathedral school and on to Oxford. In 1657 he was appointed rector of the nearby parish of Credenhill, dying in 1674 at the age of thirty-seven but leaving behind him poems that speak of his great love for his native city and the surrounding countryside, much of which went unpublished until well after his death. It might have been of Hereford that he was thinking when he wrote, 'The city seemed to stand in Eden, or to be built in heaven' (from 'All Things Were Mine').

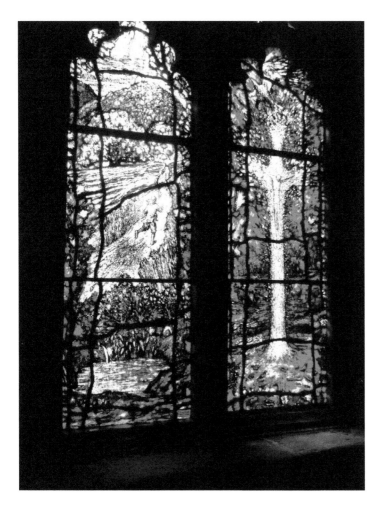

Modern stained glass in Hereford Cathedral reflecting the poetry of Thomas Treherne.

6. The Eighteenth Century: Hereford Does Its Best to Pick Itself Up

At the beginning of the century Daniel Defoe described Hereford as large and populous but 'old, mean and dirty'. This was a time of deep political rivalry, much of it left over from the Civil War, with the Whigs believing that the future they were about to create would be better than the past and the Tories believing that the world had already gone to hell in a handbasket. While the freeman of the city of Hereford, who had the right to elect the MPs, were mostly based in London and of the Whig faction, the mayor and Corporation, remaining in Hereford, were firmly Tory. This made for some violent elections. Given the size of the body of freemen, the Duke of Chandos, best known as a patron of Handel, thought, in 1727, the constituency 'extravagantly expensive'. He reckoned it was necessary to pay 500 voters 5 or 6 guineas a head to secure the return of his candidates. He was probably a little ambivalent about the city, having had to fight a duel on the Castle Green with one of the city's MPs over accusations of corruption while acting as a trustee of a local charity. No one was injured.

The Castle Green

Castle Green has been a park since the eighteenth century.

The former bailey of Hereford Castle, it is now a pleasant park but, at the beginning of the century, the Duke of Chandos proposed to turn the area into his own private pleasure garden. This was strongly resisted by the city authorities and the duke was forced to keep it open to the public. This led to the formation of the Society of Tempers, aiming to promote the pleasures of conviviality and good fellowship. In 1818 the Tempers complained that vandals had destroyed improvements they had recently made and there was an attempt to set up gates to close the green at night, but nothing came of this. It became a popular place to promenade and be seen, a tradition that carried on into the twentieth century, aided, on Sundays, by a brass band playing popular music from the bandstand near the duck pond.

DID YOU KNOW?
Hereford Cathedral once had a spire but, on Easter Monday 1786, the West Tower, which had been in a state of disrepair since the Civil War, collapsed. During the repair work it was discovered that the spire on the central tower had been weakened and, on cost grounds, it was decided to dismantle it. Spires are tricky pieces of engineering. For many years the spire on the nearby All Saints Church had a decided bend that rivalled that of Chesterfield. Because it too was feared to be unsafe, the lean was corrected in 1994. For many years the cathedral was left in ruins, but when it was eventually repaired, the results were so unpopular it too was dismantled. The current west front, by John Oldred Scott and completed in 1902, was also considered a bit too Victorian for everyone's taste.

The unloved west front of Hereford Cathedral.

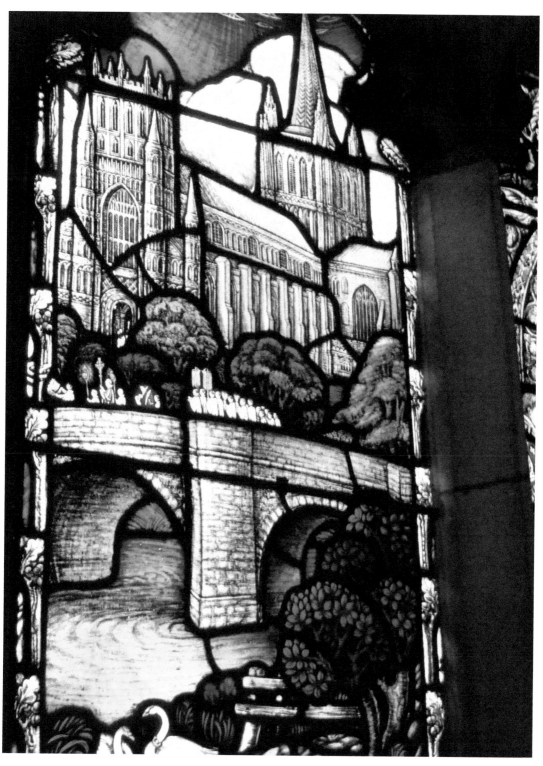

Victorian stained glass gives an idea of what the medieval cathedral would have looked like.

Hereford Gaol

To the medieval mind incarceration for long periods seemed an odd form of punishment. Those found guilty were either fined, whipped, mutilated or hanged. Those awaiting trial would be held in the Bridewell, now part of Castle Cliffe, and any punishment carried out soon after. As the population increased this was considered inadequate and an existing building on the site of the later Shire Hall was converted for the purpose, but it seems to have been easy to escape from and the landlord of the nearby Golden Fleece could not be prevented from supplying prisoners who could pay with alcohol. At the time there were over 200 offences that carried the death penalty, right down to the theft of a loaf of bread, though magistrates could commute the sentence to transportation. Hereford magistrates had a reputation for being particularly lenient. Executions, which were in public and a popular entertainment, took place either in what is now St Peter's Square or at Gallows Tump, at the crossroads opposite the rebuilt St Martin's Church south of the Wye, where a magnificent oak tree now stands. In the medieval period there was a chapel near here dedicated to Our Lady of the Hanging Gallow's Tree. Further along Walnut Tree Avenue, now pleasant suburban bungalows, was Gallows Field. Looking at the records of those hanged, it is a dispiriting litany of drunken husbands who bludgeoned their wives and petty and ill-planned thefts.

The Golden Fleece, whose landlord made a nice profit out of the gaol's prisoners.

The crossroads where the former gallows tump stood.

By the end of the eighteenth century the prison situation was considered unacceptable and a new purpose-built prison was constructed on the site of what is now the bus station with capacity for 105 inmates in cells rather than the indiscriminate dungeon that was all the previous gaol offered. After public executions were banned in 1868 there was room for them to be held in a converted coach house. The last execution took place in 1903, a roadman who had battered his wife to death in a drunken rage. The prison was closed and demolished in the 1920s. The only part left standing was the former governor's house, which is now offices.

DID YOU KNOW?
Throughout the eighteenth century Hereford was noted for producing famous actors. David Garrick, regarded as the finest Shakespearean actor of his age, was born at the Angel Inn in Widemarsh Street. Richard Kemble, born in Church Street, was also a famous actor in his day and his daughter, Sarah Siddons, was an actor who was known to reduce a whole audience to tears with the force of her performance.

The former governor's house of Hereford Gaol, the only building still standing.

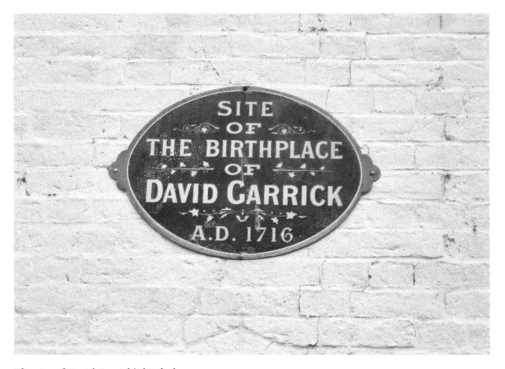

The site of David Garrick's birthplace.

7. The Nineteenth Century: A Time of Civic Pride

By the early part of the century there was a strong libertarian faction within the city, petitioning against slavery and ending the death penalty for non-violent crimes. This was countered by a strong Tory-Anglican group based around the cathedral clergy, who also strongly opposed any weakening of anti-Catholic laws. The dispute reached its head in 1820 when the cathedral organist, Aaron Hayter, and his brother were implicated in an arson attack on the cathedral.

By 1831 Hereford was described as 'a place neither advancing nor receding'. The formerly important glove trade was beginning to decline but cider was becoming an increasingly important product and the Wye navigation ensured that the city remained an important trading area. After the 1832 Reform Act, while rural areas supported the Tories, the borough of Hereford returned Whigs and latter Liberals, both more in tune with reform.

The Red Book of Hereford

In 1829 a charwoman working in the old Town Hall became so fed up with all the many bits of paper littering the place that she decided to have a tidy up. Unfortunately in the process she destroyed many of the ancient manuscripts of the city including many of the minute and account books of council meetings. Only one page of the now vanished Red Book of Hereford was recovered, being found wrapped around a pound of cheese. The woman, Esther Garstone, was convicted of larceny because she had sold some of the documents for waste paper.

The Green Dragon

On a typical weekday in 1830, as many as forty stagecoaches would arrive at this old coaching inn. In the days before the state controlled the country's transport, each would be proudly bedecked in the livery of the company that owned them – canary yellow, bright scarlet etc. – though, depending on the season, they could also be covered in liberal helpings of Herefordshire mud. By this time coaches were 8 feet tall, 11 feet long, pulled by four horses and able to take six inside passengers and twelve on the cheaper option on the top. Each company was strongly competitive, desperate to show that they provided the fastest and safest service, with coach names like Hero, Champion, Defiance and Tally Ho! Undoubtedly the fastest and smartest was the Royal Mail, with black and maroon livery, scarlet wheels, the royal arms on their doors and their guards in impressive scarlet coats. However, even in one of its coaches, travelling from Hereford to Liverpool took sixteen hours. In 1834, Jobson, Morris & Co. offered what they promised was a record-breaking service, taking only twelve hours for the journey, and that without furious driving.

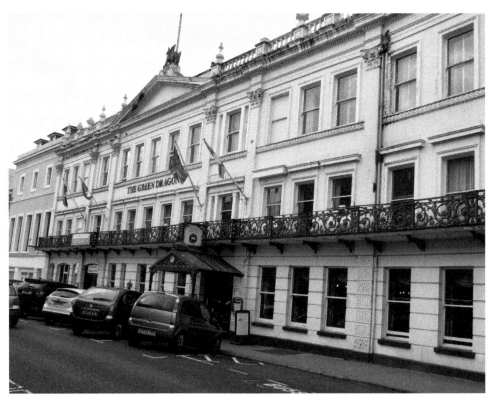

The former coaching inn the Green Dragon.

The competitive racing of coaches was leading to much concern, causing as it did frequent accidents and deaths. Sadly this once impressive coaching inn has now fallen on sad times and looks a little down at heel.

DID YOU KNOW?
Hereford had a Nelson's Column thirty years before the more famous one in London. Although a landlocked county, Herefordshire took Admiral Nelson to its heart, especially after he paid a visit to Hereford in 1802, staying at the Duke of Norfolk's residence in Broad Street and being granted the Freedom of the City in a well-attended ceremony. When news of his death at the Battle of Trafalgar three years later became known a public subscription of local citizens raised funds to erect a memorial in the Castle Green. Unfortunately the money was used up before the planned statue could be made so the memorial was topped with a simple urn. The inscription also got the number of ships captured wrong. Until the middle of the century the bells of city churches rung muffled peals on the anniversary of his death.

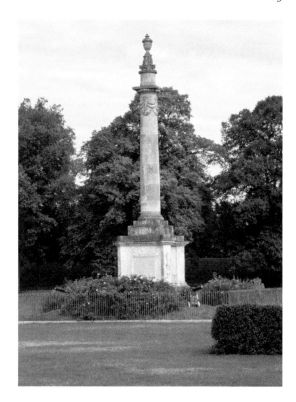

The original Nelson's Column, raised thirty years before they built one in London.

The City Arms, where Nelson stayed during his time in Hereford.

The Shire Hall, once the seat of Herefordshire government.

The Shire Hall

The Shire Hall was completed in 1817. If it reminds you slightly of the British Museum it is understandable because it is by the same architect, Sir Robert Smirke, and its classical magnificence portrays the civic pride felt at that time. For many years it was the centre of administration for the county, with law courts and council offices, but in recent years it has rather lost its way and feels a little dejected. Plans to use it as a base for the new university that is planned for the city might improve its fortunes.

The Fosse

Overlooking the last remaining part of Hereford Castle moat, now a duck pond, this building is one of the most architecturally interesting in the city. Built in 1825, it looks as if its designer was aiming to attempt something like the Brighton Pavilion but stopped short of doing anything that might worry the city fathers. The house has been attributed to Robert Smirke, the architect of the British Museum, though some doubt if he was capable of such whimsy. It has been both a private residence and offices in its lifetime, depending on the needs of the economy.

The Workhouse

The problem of how to deal with the poor has been a constant one. The line between not necessarily wanting people to starve but also not to encourage benefit scrounging

The Fosse is one of the most unique houses in Hereford.

has been a problem for the elite since both the poor and the elite have existed. In 1834 it was decided that the best solution was the creation of a network of workhouses, where the regime was so harsh that only the most destitute would apply. Husbands were separated from wives, parents from children and work was aimed at being hard and repetitive. The Hereford Union Workhouse was established in 1836, with provision for 300 inmates. Such was the poverty of the county that, by 1881, it had 319 residents. Its existence terrified the poor, especially those approaching old age with the fear that, when they could no longer work, they would end up there. Gradually public opinion moved against them and, in the 1930s, local authorities, including Hereford, were given powers to convert them into infirmaries for the poor, leading to the creation of the County Hospital. It was only with the creation of the NHS in 1948 that the last vestiges of the workhouse system were removed.

The Hereford & Gloucester Canal

It had become something of local tradition that Hereford will always adopt something new a generation after the rest of the country. It is a tradition that seems to continue, with Herefordshire Council intent on building a bypass around Hereford at a time that every other city in the UK has realised that bypasses actually makes traffic congestion worse rather than better. So it was with the Hereford & Gloucester Canal, which never

really got going before the coming of the railways took away its business. Construction actually started in 1793 but serious engineering problems and legal disputes with the Worcester & Birmingham Canal owners, who saw it as a competitive threat, delayed it, so by 1832 it had only reached Ledbury. The Hereford basin was only completed and filled with water in 1845. It had cost £141,436, three times the original estimate. Trade was not as flourishing as had been hoped and the company tried to sell the canal to one of the railway companies that were rapidly approaching. In 1852 the Hereford to Shrewsbury line was opened and Hereford became the last cathedral city to get a railway. A line from Hereford to Worcester was opened in 1861. The canal finally closed in 1881, the route being used for the Ledbury to Gloucester railway. Now the Hereford & Gloucester Canal Trust is actively working to reopen 34 miles of the canal. In the early part of the twenty-first century it was hoped that the Hereford section of the canal near the railway station would feature in the regeneration project known as the Edgar Street Grid. Unfortunately the money ran out and now even the most patriotic Herefordian would have to concede that the area around the railway station is more unwelcoming to visitors than any other city in the country.

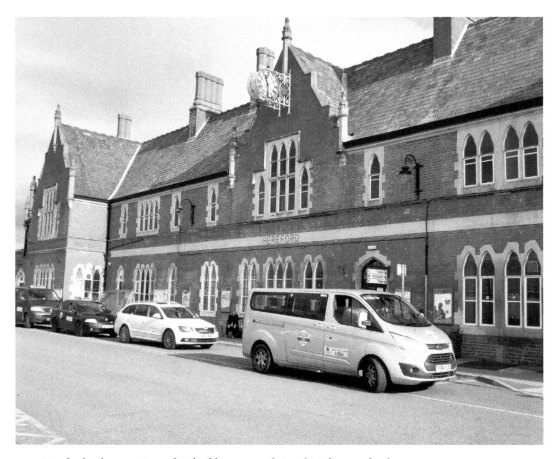

Hereford railway station, a fine building currently in a bit of a wasteland.

'Welcome to Hereford': the sight that greets visitors to the city by rail.

St Francis Xavier's

Since the Reformation anyone professing the Catholic faith was viewed with suspicion by the powers that be for fear that they were potential traitors. After the comprehensive defeat of the Jacobites these fears began to subside, and by the early part of the nineteenth century anti-Catholic legislation was being repealed and they were even allowed their own places of worship. This church was completed in 1839 and is actually an imitation of the Treasury of the Athenians at Delphi, although it looks a little cramped due to the shops pressing against it. Inside its colourful decoration gives some idea of what pre-Reformation churches used to be like but its most interesting possession is the mummified hand of St John Kemble. He was a Catholic priest quietly and secretly going about his business in western Herefordshire in the late seventeenth century. Denounced as part of the Titus Oates scare over a non-existent popish plot, he was made to walk to London to stand trial, even though he was eighty years of age. Found guilty he was sentenced to death by hanging, drawing and quartering and made to make the return journey on foot so that the sentence could be carried out. This gruesome punishment was carried out on Widemarsh Common. He was canonised in 1970 and his feast day is 22 August.

St Francis Xavier's,
where Catholics could
at last worship.

Revd John Venn

Do-gooders get a poor press these days but the reality is that society cannot flourish without them. This was especially true in the nineteenth century, before the state considered care for the disadvantaged part of its duties. Revd John Venn was appointed vicar of St Peter's in 1833. His father, another Revd John Venn, had been one of the founders of the Church Missionary Society and his nephew, yet another John Venn, was the inventor of the Venn diagram. Determined to serve the poorer members of his parish, by 1838 he had helped set up the Herefordshire Friendly Society, to help small savers that the banks would not touch, and in 1841 the Society for Aiding the Industrious, providing an early allotment scheme, soup kitchen and bulk purchase of coal. In 1847 he was instrumental in setting up a corn mill where the poor could have their corn ground at cost. Later washing baths were built to the rear of the mill, most people not having such facilities at home. Perhaps not as revered as he once was – his grave was vandalised a few years ago – he should still be remembered with affection by the people of Hereford.

John Venn's Mill
was built to help the
industrious poor of
Hereford.

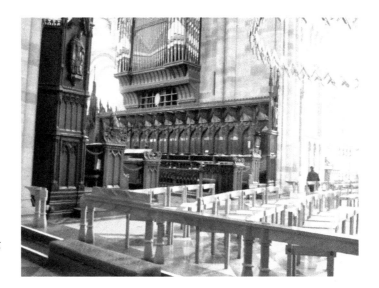

The high altar of the
cathedral is now missing
its ornate Victorian
ironwork.

Villas built in the nineteenth century to house the extended population of Hereford.

Expansion

In the latter half of the nineteenth century Hereford went through a period of development, with new suburbs being built to house a rising population as more people came from the country to look for work. In 1850 the Hereford Freehold Land Society was founded with the aim of purchasing land for development and building what would now be called social housing for the 'Industrious Classes'. The first land it purchased was in the Widemarsh area to the north of the city but it was also involved in spreading Hereford's suburbs into Hunderton to the south, Whitecross to the west and Bartonsham to the east, spreading the city's footprint wider than it had done in its first thousand years of existence and setting the ground for its further expansion in the next century.

George Cornewall Lewis

The most eminent politician to come from Hereford, he was variously Chancellor of the Exchequer, Home Secretary and Minister for War. His proud statue stands outside the Shire Hall in St Peter's Square, little regarded by passers-by, which is a pity, as his story deserves to be remembered.

At the time of the American Civil War there were many in the cabinet, including Prime Minister Palmerston and Chancellor Gladstone, who felt Britain should side with the pro-slavery Confederacy in order to protect supplies of raw cotton for the mills of

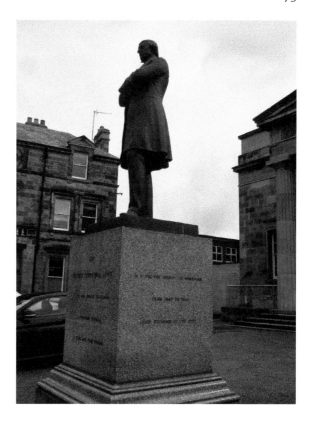

George Cornewall Lewis, the most
prominent politician born in
Hereford.

Lancashire. Lewis spoke out against this, arguing for neutrality, a view that eventually
prevailed and served Britain well when the Union became the victor. Sadly he died in
1863 before he could rise even higher up the greasy pole of politics.

The Cattle Market

Hereford, at the centre of a rich agricultural area, depended on its prosperity by providing
a thriving market for this produce. Chief of these was the Hereford cattle, the reason the
name of the city is recognised throughout the world. Developed in the late eighteenth
and early nineteenth, with their distinctive red coats and white faces, they have been
exported all over the world to form the basis of many beef industries. They also make
regular appearances in westerns, although the principal cattle of the Wild West were
actually longhorns.

At the time of the Domesday Book the market area was in what would become High
Town, outside the Saxon boundaries, and this site continued to be used for many centuries,
with regular markets held on Wednesdays and Saturdays. In the nineteenth century there
were increased concerns about the amount of cattle and their waste being allowed into
the centre of the city and an area to the north was purchased to build a purpose-built
New Market in 1856. As well as livestock it also soon developed a thriving wholesale fruit
market. However, it was its auctions of young Hereford bulls that attracted buyers from
all over the world. But fashions change and in 2011 the market was moved to a site just

The Old Market, the site of the former cattle market.

outside the city, easier for lorries to get to but weakening a link between the city and the sale of agricultural produce that had existed for a thousand years. The New Market site was renamed the Old Market and is home to department stores and fast-food restaurants.

The Butter Market

After the demolition of the old Market Hall it was felt necessary to replace it with somewhere more modern where farmers and small traders could sell their produce, as they had done under the pillars of the old hall. So a new market hall, commonly referred to as the Butter Market, was built in High Town, opening in 1861. It served this function well for over a hundred years but, in more recent times, given the pressures on retail businesses, it has struggled. Plans to turn it into a space for creative industries have so far come to nothing.

Hereford Library and Museum

By the middle of the nineteenth century many people of Hereford were keen to widen their education, including a better knowledge of the local area. The Woolhope Club, to study the natural history and archaeology of Herefordshire and surrounding counties, was founded in 1851. This led to discussions about the city needing its own library and museum and, in 1871, James Rankin, a future Conservative MP, bought a plot of land in Broad Street for that purpose. A local architect, F. R. Kempson, was chosen to compete the

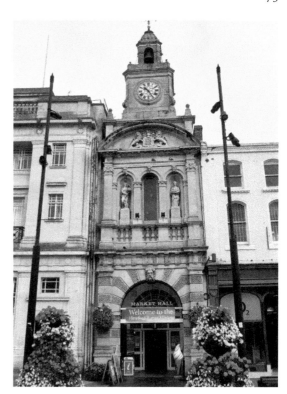

The Butter Market, where small traders can sell their wares.

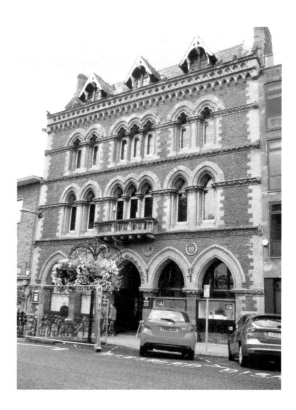

The library and museum, centre for learning and research.

commission and the result, which has been called 'Anglicised Venetian Gothic', opened in 1874. Pevsner, no great lover of Victorian architecture, in his authoritative 'Buildings of England' describes it as pretentious but the people of Hereford have generally taken it to their hearts, especially in a time of austerity when such facilities are under threat. The museum showcases a good display of the treasures and curiosities found in the county, including a large mosaic from the Roman town of Magnis (Kentchester), a stuffed calf with two heads and a 2-metre-long pike caught in the Wye.

Jordan's Boatyard

The River Wye, for people nowadays, is considered a bit of a hindrance, an obstacle to be got over. That was not true in the Victorian era, when, although its commercial use was declining, it remained extremely popular for recreational purposes. Central to this experience was Jordan's Boatyard, on the south bank of the river, run for much of this period by Dick Jordan, from a family long associated with the river. The Wye between Hereford and Ross can be tricky and needed someone who understood its currents. As well as boat hire the family also built its own craft and encouraged the sport of rowing along the river. In late August 1859 the first Regatta took place and became a popular feature in Hereford's social calendar. Dick had five sons to carry on the business but it was extremely seasonal and they needed other trades to make a living. The boatyard finally closed down in the 1950s after being badly affected by plans for a new road bridge that would eventually erase all traces of the yard.

The former site Jordan's Boatyard, now overlooked by the new bridge.

For many years boatmen on the Wye were wary of travelling along a stretch of the river from Hereford downstream for a distance of around 3 miles at any time after dark but especially around dusk, that length becoming known as 'The Spectre's Voyage'. They feared that, if they did, they would encounter the ghost of a young woman paddling a boat with unearthly rapidity. She was supposed to have drowned after being driven mad by the loss of her beloved. Like many Hereford ghosts, to encounter the spectre was a sure sign of your own imminent death.

The Salvation Army

Most of us come across the Salvation Army at Christmas, a brass band playing carols in a shopping centre, so regard it with some affection. This was not always true. In 1882, when the first Salvation Army citadel was planned in Hereford, on Widemarsh Street, it met with disruption from what the *Hereford Times* described as an 'army of hooligans'. It was common knowledge that they were being egged on by some of the local publicans, angered by the Army's firm adherence to temperance. It was only after a meeting with the Watch Committee, who were in charge of local law and order, that the plan could go ahead.

Name Changes

In earlier centuries people had a fairly relaxed view on street names. Names were unofficial and based on what could be found there. So Cabbage Lane was where you could buy your greens and then pop up to Butchers' Row to get some meat. The Victorian city fathers sought to regularise the process and remove some of the less savoury names, especially as many of them were no longer relevant. Butchers' Row, along with its neighbour Cooken Row, had already been demolished but Cabbage Lane became the much more picturesque Church Street. Bye Street, which had once lead to the now destroyed Byster's Gate, was renamed Commercial Street, Hungery Street became St Owen's Street, and Grope Lane, rather appropriately, was renamed Gaol Street.

Bulmers

The famous cider firm was founded by Percy Bulmer in 1887. He was the son of the vicar of Credenhill and his mother, worried by her son's poor health as a child, advised him to find a career in either food or drink because 'neither will ever go out of fashion'.

Joined by his brother Fred, they bought land in Ryeland Street, Hereford, and built a factory that was soon producing a popular drink for the pub trade. This was a time when cider manufacture was moving away from every farmer producing his own to more specialised, factory production and the Bulmers were on trend. The brothers' partnership flourished for thirty years and, even after they had both died, their children and grandchildren continued to run the business for many years, eventually bringing in outside managers. This did not work out as well and, in 2002, a £3.3 million black hole was discovered in the accounts, resulting in it being taken over by the huge brewers Scottish and Newcastle, ending the family involvement. This company was itself taken over by Heineken in 2008. Today the link to only using Herefordshire apples has loosened, though the name Bulmers is still recognised in many pubs and supermarkets.

Bulmers' original factory, now a museum.

Cider mill and press.

The Vicky Bridge

Vicky Bridge, as it is known locally, should be more properly called the Victoria Suspension Bridge. It was built in 1898 to commemorate the Diamond Jubilee of Queen Victoria a year earlier and paid for by public subscription in an era when local authorities had no money for such improvements. Before the bridge was built the only way of crossing the river was to walk to the main bridge or wait for the ferry that used to operate at this point.

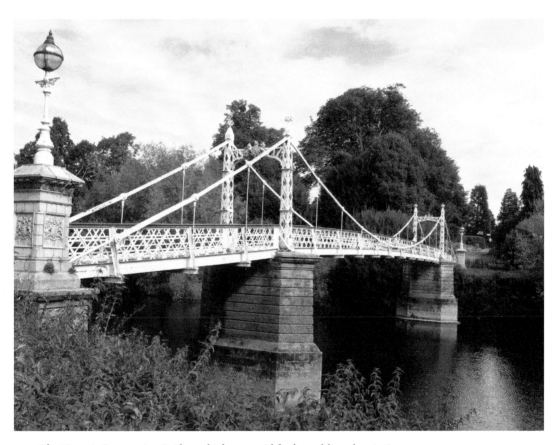

The Victoria Suspension Bridge, which was paid for by public subscription.

8. The Twentieth Century: Hereford Faces the Future

The Town Hall

Completed in 1904, the town hall is a fine example of Edwardian confidence, which you will either think a remarkable piece of architecture or extremely ugly. Inside the confidence of the period is reflected in dark oak panelling that would not be out of place in a five-star hotel. The town hall is the custodian of the city regalia and charters, which have recently been given a new exhibition case and are well worth viewing.

The Town Hall is currently being refurbished.

Edward Elgar

Though born in Worcester, Elgar is also closely associated with Hereford, living at Plas Gwyn, Hampton Park Road (now, inevitably, converted into flats and renamed Elgar Court) from 1904–12. Here he enjoyed his most creative period, composing the 'Introduction' and 'Allegro for Strings', both symphonies and his violin concerto. The eleventh of his *Enigma Variations*, 'G.R.S.', is based on a walk by the River Wye with the organist of Hereford Cathedral, George Robertson Sinclair, when Sinclair's bulldog Dan fell into the river. Although now regarded as part of the musical establishment, Elgar felt himself something of an outsider. He was self-taught, a Roman Catholic and of lower middle class origins. Perhaps because of this he did not achieve recognition until well into his forties.

The Elgar statue in the Cathedral Close.

A statue to the dog Dan, marking the spot where he fell into the river.

Florence Canning

Many people would recognise the name Emily Davison, the suffragette martyr killed while trying to attach a flag to the king's horse, Anmer, during the 1913 Derby (the horse was uninjured, although the jockey, Herbert Jones, said he was forever haunted by 'that poor woman's face' and committed suicide in 1951) but Hereford also has its suffragette martyr, Florence Canning. She was the daughter of the vicar of Tupsley, and a gifted artist but decided to put this aside to devote herself to the cause of the militant suffrage movement of Emmeline and Christabel Pankhurst. Her parents and many of the clergy of Hereford, including the bishop, John Percival, supported the cause and High Town was the scene of a large rally in support of a woman's right to vote in 1908, although an egg was thrown, narrowly missing Christabel Pankhurst. As successive governments refused their demands the suffragettes took stronger action, culminating in a march on parliament on 18 November 1910, but this was met by violence, including sexual assault, by the police and some male bystanders. The suspicion has always been that this was encouraged by the Home Secretary Winston Churchill in order to humiliate the protesters and teach them a lesson, though he always denied this. Florence Canning was one of those injured. Despite convalescing at Eagle House, Batheaston, near Bath, a suffragette retreat, her health never recovered and she died on Christmas Eve 1914. She was buried in Hereford, her coffin covered in flowers of the suffragette colours, purple, white and green.

Winnie Mailes. Linda Illman. Phyllis White. Connie Bragg.

Nellie Rutherford. Peggy Baird. Cissie Beavan. Violet Corey.

The faces of the children who died in the tragic Garrick Theatre fire.

The Garrick Theatre Fire

The worst disaster to befall Hereford in the First World War happened, not in the trenches, but at the Garrick Theatre on Widemarsh Street. In April 1916 a concert was held at the Garrick to provide extra comforts for the local men serving in the Herefordshire Regiment and Shropshire Light Infantry. The amateur cast included many young daughters of serving soldiers. Like any tragedy, reports of what happened that night are confused but the girls were dressed in white cotton wool costumes, against theatre regulations, to portray snow maidens. As they were leaving the stage one of the costumes caught fire, quickly spreading to others and causing panic in the auditorium. At the end of the night six small girls were dead and two died later of their injuries. Hereford, already all too used to telegrams bringing dreadful news, was plunged into deep mourning. A public funeral was held in the cathedral for five of the children, one girl's parents preferring a private internment. Thousands lined the streets to pay tribute as the cortege passed and flags flew at half-mast. The horror was blamed on a discarded match from an irresponsible smoker.

Brian Hatton

Who knows what potential was lost in the carnage of the First World War? For one Hereford man we can see what he achieved at an early age and can only guess what he would have gone on to achieve. Brian Hatton was a drawing prodigy. At the age of ten he won the Royal Drawing Society's annual competition. Mentored by established artists, he studied at Arbroath and Paris and set up studios in Hereford and London taking on portrait commissions to earn money. However, it was the countryside around Hereford that really inspired him, especially the horses and country people that worked within this landscape. When war broke out he joined the Worcestershire Yeomanry and was killed in Egypt in 1916 aged only twenty-nine. His legacy is the paintings of that lost Edwardian era and the bitter thought, as with all those lives lost, of what might have been.

DID YOU KNOW?
The man who discovered ley lines was born in Hereford. Alfred Watkins was born in 1855, when his father the landlord of the Imperial Inn in Widemarsh Street. After leaving school Alfred was employed by his father as a brewer's representative, which allowed him to travel country lanes in a horse and cart, a perfect way to get to know the land. He was also a keen early photographer and invented one of the earliest light exposure meters. Although he became a successful entrepreneur, he still spent much of his free time travelling through rural byways and his photographs have become a vital resource portraying that lost world of a hundred years ago. In the 1920s he had a revelation: the straight lines that connected ancient sites. He described it as 'a network of lines, standing out like glowing wires, all over the surface of the country, intersecting at the sites of churches, old stones and other spots of traditional sanctity'. The book he wrote on the subject, *The Old Straight Track*, was published in 1925 and is still in print. Although many have ridiculed the idea of ley lines, they do add an element of mystery to a walk in the countryside.

Brienton, a suburb of Hereford much loved by Brian Hatton and featured in many of his paintings.

Ghost Fever

On a cold December night in the 1930s a policeman was walking his beat in the Cathedral Close when he spotted a hooded figure near the building. When he called out the spectre completely vanished, giving him quite a shock. A few days later a printer saw the same thing and gradually more people came forward to claim they had seen what they were sure was the ghost of a monk. Suddenly this became a popular entertainment, hanging around the close at night hoping to spot the fearful sight. Many said they had been rewarded for their wait with a glimpse of the ghost, one woman fainting at the appearance of the hooded monk. Soon people were coming from as far afield as Cardiff, catching the 2.00 a.m. train, and the respectable residents of the close complained to the police about the noise. The cathedral authorities made a declaration that the close was definitely not haunted and historians pointed out that the cathedral was never a monastic establishment so no monks would have been present. Soon, like all crazes, the excitement died down and was forgotten.

The Bishop's Meadow

The area south of the Wye, although outside the original boundary of the city, has played an important part in Hereford's history. The Rowe Ditch, a large embankment on the western edge, was long thought to have been dug by the besieging Scots in the Civil War,

but recent archaeological excavations have shown that it has an older story, and was part of the Saxon defences and, in the medieval period, where industries considered too noxious to be within the city could be sited. In the eighteenth century the land was owned by the bishop of Hereford (whose palace still stands on the opposite bank of the Wye), although the populace were allowed access to it. This situation was formalised in the nineteenth century, with the land donated to the city to allow public access in perpetuity. In 1936, following the death of George V, a fund was established to set up a network of playing fields across the country to commemorate the name of the king and land to the east of the Bishop's Meadow was devoted to this purpose so that this large green space now provides a much needed place of recreation, with a swimming pool, putting green and football pitches as well as a delightful riverside walk.

Further Expansion

Between the wars new suburbs were built on the south side of the river, the population rising to 50,000. Currently it is about 60,000, though Herefordshire Council hopes that this can be increased to make the local economy more viable.

The George V Playing Fields.

Further expansion led to further housebuilding.

Anthony Hall

Did the rightful king of England live in obscurity in Hereford in the 1930s? Anthony Hall, who liked to be known as Anthony I or Anthony Tudor, was born in London but the family moved to Herefordshire at the turn of the new century. Having served in the First World War as an ambulance driver, he later joined the Shropshire Constabulary, rising to the rank of inspector and an early expert on fingerprinting until the death of his father left him with enough money to pursue his claim to the English throne. His assertion was that he was a direct descendant of an illegitimate son of Henry VIII and Anne Boleyn otherwise unknown to history. He wrote an open letter to George V, ordering him to vacate Buckingham Palace and at one point challenged the king to a duel, the loser to be beheaded. A powerful speaker, his public meetings were extremely popular, especially as one of his key promises was that he would increase the alcoholic strength of beer.

We now know, from recently released royal correspondence, that George V was actually quite concerned about Anthony Hall and discussed with Home Office officials if there was any way of declaring him insane, although psychiatrists who talked to Hall found him perfectly lucid.

In 1936 he held a meeting in St Peter's Square when he was arrested and charged with obstruction, assaulting a police inspector and breach of the peace. Despite promising to make Hereford his capital when he became king, he was fined £20.

▲ Last of the Tudors? – Hereford's Anthony Hall.

Anthony Hall, the rightful king of England?

Daws Road, Hall's HQ in his fight to become king.

During the Second World War the nation had other things on its mind and Anthony Hall stopped advertising his claim, instead working as a shell inspector at Rotherwas Munitions Factory. He died in 1947 and is buried in the small village churchyard of Little Dewchurch, south of Hereford.

Rotherwas Munitions Factory

Apart from the blood of its young men and women, the greatest contribution that Hereford made to the two world wars was the production of artillery shells at the munitions factory to the south of the city, first opening in 1916. To meet labour shortages young women from Wales and Ireland were employed there during hostilities, but the two groups did not get on together. At one point the Irish were heard to make nasty comments about Welsh soldiers and the Welsh girls retaliated with fists and the Irish responded with names 'not found in any dictionary' according to one observer, so that the two groups had to be separated. The factory was closed in 1920.

It had to be opened again in 1939. It was so important to the war effort that it unfortunately earned a visit from the Luftwaffe on 27 July 1942. Tragically the lone aircraft appeared just as the morning shift were arriving and twenty-two people were killed. Afterwards the story was put about that this was a bomber that had got lost while heading for Birmingham but undoubtedly the Germans knew more about what was happening in Hereford than the British authorities wanted to admit. Further disaster

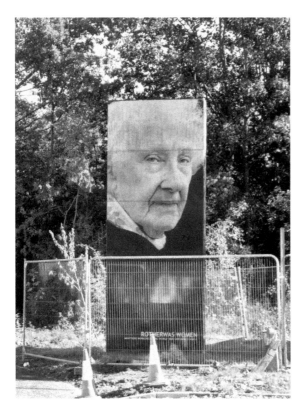

Rotherwas Munitions Factory commemorates some of the people who worked there during the war.

Rotherwas Munitions Factory.

Skylon Enterprise Park is about to open for business.

was narrowly averted in May 1944 when a bomb exploded in a filling house, killing two people. Windows were shattered all over Hereford and only brave action by the staff and emergency services averted further destruction. Five George Medals and many other bravery decorations were awarded. Closed after the war and for many years left vacant, the site has recently been renamed the Skylon Enterprise Park, which aims to attract new industry to the city, with particular emphasis on what is now called 'defence' rather than anything nasty like munitions.

DID YOU KNOW?
Skylon, the centrepiece of the 1951 Festival of Britain, was manufactured in Hereford. After the Second World War the government decided to disperse strategic manufacture and several light metal factories opened in Hereford. Painter Bros in Holmer won the contract to build the Skylon, a futuristic, slender, vertical, cigar-shaped steel structure erected on the South Bank in London. It gave the illusion of floating above the ground and caught the imagination of visitors. It seemed to represent the bright scientific future they believed was coming. It was destroyed in 1952 on the orders of Winston Churchill, who saw the whole festival as socialist propaganda by the previous Attlee government.

The Special Air Service

One reason the quiet city of Hereford gets into the news is that it is the home of the SAS. The military formation was founded in 1941 by maverick Colonel David Stirling. Its title was a piece of Allied misinformation, hoping to fool the Germans into thinking it was just another paratroop regiment. In fact its first operations were operating by jeep behind German lines in north Africa. These first attacks often did not go well but eventually it fell into its stride and by the time it was fighting in France and Germany at the end of the Second World War, it was a formidable fighting force, so much so that any personnel captured were liable to be summarily executed.

After the Second World War it took part in various post-colonial disputes but it was in tackling the Iranian Embassy siege in 1980 that the SAS captured the public imagination. Only recruiting from within the British Army, it has a notoriously gruelling five-week selection process, of which only 10 of 125 candidates are likely to pass. Much of its operational workings are by necessity secretive but it is thought to have around 500 regular personnel. For many years it was based just a mile to the south of the city centre at Bradbury Lines (later renamed Stirling Lines), but this site had the disadvantage of having a public footpath running through the centre of it and a busy railway line along a perimeter. In 1999 it moved to a more private base at Credenhill, some miles to the west of the city. Its badge is a downward pointing Excalibur, with wings of flame, and the famous motto 'Who Dares Wins'.

The SAS insignia.

Memorial to the dead at St Martin's Church, near the SAS's former base.

Hereford United

The football club, known affectionately as 'The Bulls', was founded in 1924 and based in Edgar Street, north of the city centre. Its motto was 'Our greatest glory lies not in never having fallen, but in rising when we fall,' which says something about the mixed fortunes of the club. The players originally played in an all-white strip but, at the end of the Second World War, they were unable to obtain white material and had to use old blackout curtains for their shorts, resulting in a change of strip to black shorts and white shirt. The club's greatest season was 1971/72, when they beat Newcastle United in the FA Cup and were promoted to the Football League. Success continued and they were in the Second Division during 1976. From that high point it was a difficult fight for survival, falling back to the Fourth Division and eventually out of the Football League altogether, although they did return to the Fourth Division briefly in the 2008/09 season. The club was expelled from the Conference in 2014 for financial mismanagement and dissolved the same year, a sad end to a proud club. A successor club, Hereford FC., is now rising up the leagues.

Hereford United's Edgar Street ground.

The House That Moved

In the 1960s Hereford, like many cities in the UK, went through a process of civic vandalism in order to look like every other city in the UK. One of the greatest losses was the Kemble Theatre in Broad Street, which was replaced by a truly awful modern office block. Another casualty was the impressive Greenlands department store in High Town, whose Georgian stone building was replaced by brutalist brick. As part of this development another casualty would have been a timber-framed shop, built in around 1600, to the west of High Town. However, this caused such a furore that the developers reluctantly agreed to put the whole building on wheels and drag it to the centre of High Town where it waited the completion of the modern building and was then wheeled back to sit on top of a modern façade. You have to look up to see it and the success of the process I will leave to your judgement.

The house that moved.

The Courtyard

Once enjoying the benefit of two theatres, by the middle of the twentieth century Hereford had lost both of them and they had not been replaced. The Garrick, in Widemarsh Street, became a multi-storey car park and the Kemble in Broad Street became a truly awful modern office block. In the 1980s the old swimming baths in Edgar Street, which had been superseded by a more modern pool to the south of the city, was converted into the New Hereford Theatre but was never considered completely satisfactory.

The answer was the Courtyard Centre for the Arts. Opened in 1998, with a main theatre reflecting an Elizabethan or Inn Theatre (hence its name), a smaller studio space and rehearsal rooms, as well as a restaurant and café and art exhibition areas, it quickly established itself as a popular venue for Herefordians.

A modern office block replacing the Kemble Theatre.

The Courtyard, the centre for culture in Hereford.

Acknowledgements

First my thanks to Amberley Publishing, especially Angeline Wilcox, Jenny Stephens, Nick Grant and Marcus Pennington for getting this work off the ground. My grateful thanks to the following people whose expertise and knowledge were invaluable to my research:

The Chapter of Hereford Cathedral for permission to include photographs taken within the cathedral precincts.
Dr Rosemary Firman and her colleagues at Hereford Cathedral Library.
Rhys Griffiths and his colleagues at Herefordshire Archive and Record Centre.
Jacqueline Jonson and Marianne Percival, Hon. Librarians, Woolhope Naturalists' Field Club.
Anne Cook.
David Nicholas and Tim Cook, who took over some of the driving duties.

Bibliography

Hopkinson, Charles, *Herefordshire Under Arms* (Bromyard Local History Society, 1985)
Johnson, Richard, *The Ancient Customs of Hereford* (Richards of London, 1868)
Johnson & Shoesmith et al., *The Story of Hereford* (Logaston Press, 2016)
Olszanska, Claire, *The Medieval Close* (Hereford Cathedral Perpetual Trust, 2010)
Pevsner, Nikolaus, *Herefordshire (The Buildings of England)* (Penguin Books, 1963)
Phelps, David, *Bloody British History: Hereford* (The History Press, 2012)
Phillips, Elizabeth *Hereford, The City and Its People in the Late Tudor and Early Stuart Period* (Phillips, 2004)
Weaver, Phillip, *Dictionary of Herefordshire Biography* (Logaston Press, 2015)
West, J. & M., *A History of Herefordshire* (Phillimore, 1985)

Hereford Journal Archives, 1793–1910
Hereford Times Archives, 1832 to present
Transactions of the Woolhope Naturalists' Field Club, 1851 onwards

www.historyofparliamentonline.org